THE
CAROUSEL
ANIMAL

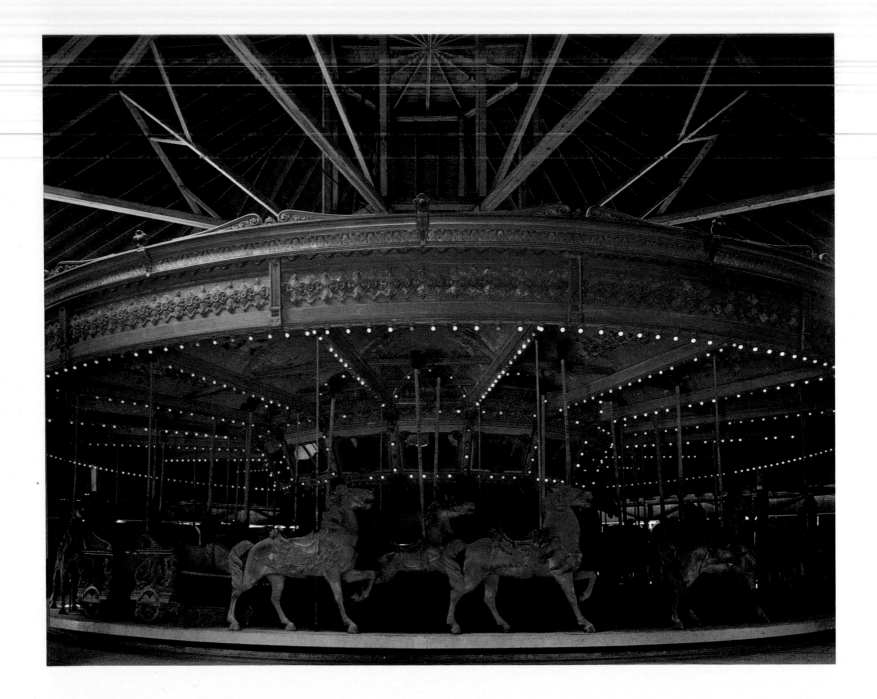

THE CAROUSEL ANIMAL

Text by Tobin Fraley
Photography by Gary Sinick
Preface by Nina Fraley

Chronicle Books • San Francisco

First Chronicle Books edition 1987

Text copyright © 1983 by Tobin Fraley

Photographs copyright © 1983
by Gary Sinick
Printed in Japan by Dai Nippon
Printing Co.

Library of Congress Cataloging in Publica-
tion Data available.

Typesetting: Jennifer Tayloe
Production: Richard Schuettge

Distributed in Canada by
Raincoast Books
112 East 3rd Avenue
Vancouver, B.C. V5T 1C8
10 9 8 7 6 5 4

Chronicle Books
275 Fifth Street
San Francisco, California 94103

For Karen Zukor

Every book is created with the help and guidance of
many people. Since this book is no exception, I would
like to thank the people who contributed their knowledge,
expertise and assistance toward making this book possible:
Tracey Cameron, Ervin and Eleanor Chell, John and
Cathy Daniel, John O. Davis, Marion and Bill
Dentzel, Ed Evans, Maurice and Nina Fraley, The
Freels Foundation, Fred Fried, Marriott's Great
America Park in Santa Clara, Phil and Jan Herrero,
Lise Liepman, Pat and Lynda McEvoy, Merwin and
Selma Orenstein, Michele Salmon, Marlana B.
Sinick, Linda Tiffany, Donald Vascimini, and Gary
and Bonnie Wolf.
With special thanks to:
Richard Schuettge, Rol and Jo Summit,
and Marge Swenson.

Contents

Preface

Let's ride the Carousel! We all know what it means. Little children jumping with excitement. Parents waving as their youngsters circle past and smiling as they remember their own youthful fantasies astride a carousel pony; King Arthur's knights riding to the joust; a cowboy heading west over the plains. What is there to remember about these wooden horses but their color and motion and the music and lights surrounding them? Why does a carnival ride, even one we remember and love, need a book to explain it?

The carousel horse, during the last decade, has become a treasured piece of Americana, sought after by hundreds of collectors, researched and classified, resurrected from decay and neglect, and honored in parks, homes and museums across the country. Its significance starts as a personal search for a time past. The horse in the antique shop window takes us back to our childhood, to an age of innocence when we believed that dreams would come true; that wanting something could make it happen.

When I look at these beautiful carvings, I see another dream. In a broader sense, I see these wooden animals as a part of the fabric of America. Quite literally, they represent the period during which they were carved: the age of the immigrant, from 1870 to 1920. During that period in history, when the Industrial Revolution had finally arrived from England, we, as a nation, truly felt that this was the land of opportunity. Nine million immigrants in thirty years arrived at our shores and, like children, they, too, believed in a dream; a dream of living their lives free from the constraint of a ruling class, free to try for something better.

From this immigrant horde came the men who carved horses, with skills and concepts born in European roots. We owe a tremendous debt of gratitude to someone like Frederick Savage of London who had so much to do with improving the mechanism that made it all possible. His improvements made larger and more elaborate rides feasible. Carousels were being carved in England and Germany in fair sophistication before they became popular in America.

And what a unique amalgam is this carousel! It is a mechanical device, a product that joyously expresses its industrial roots. Propelled by electricity, a conglomerate of meshing gears makes this wonderful machine go round and round. If you ride a carousel without the overriding sounds of the band organ music, the voice of the machine is clearly heard. Decorating the outer rim of this metal tribute to the foundryman's skill, are the remnants of a period of handcraft, of skills that were being driven out of existence by manufacturing and retail trade. When the railroads reached small-town America, the craftsman was turned into a merchant, selling the products of the big city's factories. The carousel gave employment to a small group of artisans and gave them an opportunity to continue to express their feelings through their artistry. What they expressed was that they lived in America.

Nina Fraley

6

The Carousel Animal

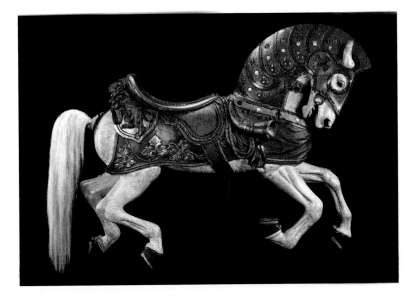

Those magical childhood moments spent whirling through a myriad of lights while perched atop a fiery steed remain as precious memories throughout life. Yet, if those memories are examined closely they may not tell us that those horses were ornately carved with flying manes or that they moved up and down. Were they even horses at all? Perhaps some were fanciful rabbits or ferocious lions or tigers, or even snarling monsters from the sea. Since, as children, these details were superfluous to the enjoyment of the ride, they tend to fade with time. However, with the renewed interest in carousels many people are not only rediscovering these details but are for the first time seeing the artistry that went into making these fine crafted carvings from our past.

In its simplest form, the carousel entertains its patrons by spinning them around a turning pole while they cling to the end of a rope. Although it is not known exactly when these devices were first developed, a game of this sort appears in a Byzantine bas-relief from 500 AD. Accounts of these rides continued to filter into western Europe from travellers who had ventured east, but it wasn't until the 17th century that the beginnings of the modern carousel first appeared.

The word carousel is derived from *carosello*, the old Italian word meaning "little war". This describes the Arabian game Spanish crusaders witnessed and brought to Italy. They saw skilled horsemen tossing and catching clay balls loaded with scented oil. The losers of this game were quite evident and carried their defeat with them for days.

A form of this game found its way, by means of royal emissaries, to the court of the French King, Charles VIII, and was soon transformed into an event of magnificent pageantry called *carrousel*. By 1662, when Louis XIV held

Le Grand Carrousel in a square still referred to as *Place du Carrousel*, several other games had been added. One of these was the medieval sport of ring piercing once played by the Moors. It called for great concentration and excellent riding ability, for the participant had to pierce a small ring with his sword while riding at full speed. To practice for these events, models of horses were placed on beams that encircled a central pole. Power was supplied by a horse or servant while the riders attempted to spear the ring hanging outside the perimeter of the horses. This practice machine soon became popular with other members of the court including ladies and children. As local craftsmen began to produce these relatively simple devices they found that demand was not limited to the nobility.

The popularity of this ride spread throughout Europe, appearing in both small local parks and in such places as Tivoli Gardens. However, the weight and size of the carousel was limited by the strength of the power source. It was not until 1870 when an Englishman named Frederick Savage put steam power to the "roundabout" that it took on the stature that we know today. Amusement parks and fairs began to spring up with as many as ten to fifteen steam powered whirling rides, thrilling thousands of patrons a day. One had a choice of riding Venetian gondolas, rolling boats, carts, buggies and, of course, a variety of animals—the most popular being pigs, roosters and horses.

As the demand for Savage's "roundabouts" grew, so did the number of his competitors, both in England and in France and Germany. Of the more than fifteen companies started, the four most successful were C.J. Spooner and Arthur Anderson in England, Frederick Heyn in Germany, and Gustave Bayol in France.

By 1900 Spooner and Anderson were creating animals in what had become a distinctively English style consisting of elaborate carvings which covered saddle, trappings and much of the horse itself. Many of the animals could carry more than one rider; others wore popular first names painted on their necks. But the most distinguishing characteristic of English animals was that the outer or romance side was on the left. This is because English carousels travel clockwise. American and other European carousels travel counterclockwise, allowing riders to grasp for a brass ring with their right hand. The English carvers realized that if their carousels went counter-clockwise, riders would tend to mount their steeds improperly, and as any equestrian knows, a horse must always be mounted from the left.

While Frederick Heyn was manufacturing mostly horses in his Neustadt an der Orla shop, Gustave Bayol was producing primarily menagerie figures in his factory in Angers. Among the more popular animals were cows with udders and brass horns, pigs, roosters, rabbits and cats. Bayol's carousels usually carried only one species of animal. A machine full of fish or pouncing cats was quite common throughout France.

Although similar in style, Heyn's horses and those of his German contemporaries were less ornate but more elegant than their English counterparts. Heyn limited carving flourishes to the trappings while creating expressive and refined facial features. The result was an animal with a personality depicted through character rather than embellishment. This same idea was to be taken even further by many of the American carvers.

There is evidence of carousels in the United States as far back as 1825. It was not until 1867 that the seeds of the American carousel industry took root, when a young man named Gustav Dentzel built his first carousel.

Dentzel arrived in America in 1860 at age 20, settling in Philadelphia where he opened a cabinet shop. Carousels were not unknown to Gustav, for his father, Michael, had carved and assembled one of his own in Germany in 1837. Michael travelled with it from town to town making a modest living selling tickets to the ride. So, it is not surprising that his son's plans were to follow the same path.

After building his first machine, Gustav Dentzel took it to several towns making money from its operation. This venture proved so successful that he changed the name of his cabinet shop to "G.A. Dentzel, Steam and Horsepower Caroussell Builder—1867". Despite the name he continued to operate the horse driven machines for most of his income.

It was not until 1880, when Frederick Savage's ideas about steam power caught on, that the popularity of the rides began to increase. By this time, a competitor had entered the market.

Charles I.D. Looff joined the carousel industry with his first machine in 1875, carving a menagerie of animals from scrap wood gathered from the furniture company where he worked. He opened a shop in Brooklyn and soon turned out his second carousel, much more refined than the first, and installed it at Coney Island. Looff's creations, like Dentzel's, were reminiscent of the German style of carving. Both companies paralleled each other in design and production until the mid-1880's when the newly developed electric trolley had a profound effect on the amusement industry.

When the major American cities built this new form of public transport they did their best to plan for future expansion by constructing the trolley systems well past the city limits or out to a natural barrier such as a beach or river. These areas proved to be ideal locations for amusement parks, since land was cheap and access was easy. They began to spring up all over the country acquiring the befitting name of "trolley parks".

With the creation of trolley parks the carousel industry flourished. Dentzel's designs became more realistic than before with close attention being paid to muscle detail and elegance in stance and head position. He also added a greater variety of animals, gathering ideas from travelling circuses and natural history museum displays of African creatures.

Looff aspired to a more fanciful design both in his carousels and the buildings which housed them. Glass jewels and bevelled mirrors were added to trappings; leg positions and manes were more animated. The animals' appearance was further enhanced by the addition of electric lights to the carousel structure and by the use of colored glass in the windows of the building. The overall richness of this effect became one of his trademarks.

In 1884 a third style was first developed by Charles Dare, then copied by his more successful competitor the Tonawanda Engine and Machine Co. owned jointly by James Armitage and Allan Herschell, and later reorganized as the Armitage Herschell Company of North Tonawanda, New York. These horses were small and simple in design, manufactured with travelling shows or small country fairs in mind.

Despite revisions in design and a changing and expanding market, these three basic styles remained intact over the next thirty-five years. The Philadelphia Style is represented by the elegance and realism of Dentzel and later by the Muller Brothers, and the Philadelphia Toboggan Company. The Coney Island Style encompasses the spirited carvings of Looff and his protégés, M.C. Illions,

Charles Carmel, Solomon Stein and Harry Goldstein. The simpler animals of the Country Fair Style are represented by the horses of Charles W. Parker and by the Armitage Herschell Company and its offspring, the Herschell-Spillman Company, Allan Herschell Company, and Spillman Engineering Corporation.

As with many manufacturers, the seeds of competition are nurtured within the parent company, and so it was with the carousel industry, particularly with Looff. As business increased in the 1890's, his staff of carpenters, carvers, and painters also increased. Among the forty talented craftsmen were four young carvers who were to later form their own companies—Carmel, Illions, Stein, and Goldstein.

Of those four, M.C. (Mike) Illions was probably the most imaginative and prolific. Within five years of his arrival in New York in 1888, Illions' reputation as a master carver spread throughout greater New York. He not only carved animals for Looff but created sculptures in both wood and stone for churches and other public buildings. He also created highly ornate façades for circuses and carnivals.

In 1900 Illions was offered the job of refurbishing a fire-damaged Looff carousel at Coney Island. The enthusiasm he had for the job is apparent as this machine had the fanciest and most spirited animals yet produced in the industry. This flamboyant interpretation characterized Illions' style throughout the life of his company.

When Charles Carmel first opened his own factory, he borrowed freely from the distinctive features of the animals of Illions, Looff, and Stein and Goldstein. Then, with some ideas of his own, he went on to create what many consider to be the classic Coney Island style horse.

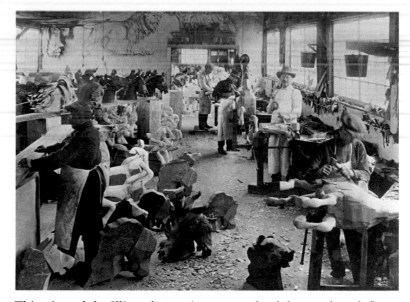

This view of the Illions factory is an example of the usual work flow. The roughed out horse heads in the foreground wait for the Master Carver. M.C. Illions, on the right, looks up from his work.

Unlike most of his competitors, Carmel created horses exclusively for framemakers, who would construct whole machines and put their name on the finished product. As far as is known, Carmel's name has never appeared on a carousel nor is there a signature horse existing, although the likenesses of both himself and his wife appear on the cantles of several figures.

Unlike Carmel, Solomon Stein and Harry Goldstein created carousels mainly for their own use, setting them up in various locations and retaining ownership. Like the other carvers of Brooklyn, Stein and Goldstein took their basic styling from Looff but were soon carving horses unique in the industry. Flowers in deep relief flowed down

the bridles and across the trappings; huge buckles held the elongated saddles to the horse. But, most of all, the lines of the trappings, saddle and mane all flowed gracefully with the motion of the animal.

Meanwhile, the Dentzel Company had expanded its facilities and by 1903 was delivering five to six carousels a year. Dentzel's business was strong enough not to be affected by competition, but when two young brothers left the Dentzel factory to start their own business, Gustav was both hurt and outraged. As young boys, Daniel and Albert Muller had been cared for by the Dentzel family when their father died. They were treated as his sons and were taught the business, so when they left against Gustav's wishes they were banished from the family.

Under Daniel's leadership they formed D.C. Muller and Brother, producing in the next few years the most finely detailed and realistic horses ever made. For his inspiration Muller drew upon both the Civil War and the circus, carving with such clarity that the trappings of his horses seem as if they can be unbuckled and removed. He went so far as to carve the stitching holes in his saddles, inserting heavy thread to complete the illusion of leather.

Despite Muller's talents as a carver, orders for their carousels were few. Perhaps this was due to his inability to compete with his better staffed and better equipped former employer. Whatever the reason, the Muller brothers closed shop in 1912 after building fewer than ten carousels.

In 1918 the Mullers were rehired by the Dentzel Company, now under the direction of Gustav's son, William, who had inherited the family business after his father's death in 1909. During the interim, between the closing of the Muller's shop and their return to Dentzel, they worked for and influenced the design in several carving shops including the Philadelphia Toboggan Company.

The Philadelphia Toboggan Company was originally formed in 1900 by Henry Auchy and Chester Albright for the purpose of manufacturing amusement rides. Mr. Auchy's desire to include carousels in their new product line drove him to search out and hire some of the best carvers available. After producing several experimental carousels, Auchy and his partners decided to go into full scale production.

The Philadelphia Toboggan Company's precise record keeping and cataloguing of each machine has been of great help in following their stylistic changes. The earlier, rather plain horses with sweet expressions were transformed into larger, fancier creatures by 1910 and by 1914 had developed into more muscular, compact animals bearing highly ornate trappings. Their last carousel, #89, was produced in 1934, several years after all the other companies had either gone out of business or were producing simplistic, machine-carved animals.

While the manufacturers in Philadelphia and Brooklyn were producing grand carousels for use in permanent locations, two other companies were turning out horses to fill a different need. The Herschell-Spillman Company and the company of C.W. Parker carved horses mainly for travelling carnivals. These animals were smaller, lighter and manufactured for easy handling and transportation. This meant sturdy parallel leg construction, simple trappings and either very small or replaceable ears.

For Charles W. Parker, carousels were only one of the many aspects of his Great Parker Amusement Company. Official Parker stationery also offered mechanical shooting galleries, cylinder pianos, carved

wagon showfronts, and all kinds of mechanical and electric shows. Parker's interest in the amusement industry started when he purchased a portion of a travelling carousel in 1892. Through reinvestment he built an empire that by 1904 had four complete travelling carnivals based near his factory in Abilene, Kansas. As business grew, Parker needed new facilities, so he moved to Leavenworth where his company continued to flourish. By 1915 his plant was turning out one carousel a week.

Colonel Parker spent the first 20 years of carousel production searching for his own design, initially copying his rival to the east, Herschell, then fashioning his horses after Looff, until settling on a style that today is unmistakably his own. His horses have extended legs, simple carving to designate muscles, and metal horseshoes with Parker's name stamped on the bottom.

While Parker's empire was growing so was the partnership of Edward Spillman and Allan Herschell, who were the most prolific of all carousel manufacturers. In their North Tonawanda factory they offered five basic styles of carousel: a two abreast with simple horses, a three abreast with simple horses, a three abreast with better horses and some menagerie, a full menagerie, permanent location machine, and a very fancy, full menagerie permanent machine. Herschell-Spillman also produced the most varied array of menagerie figures ever offered—pigs, goats, roosters, zebras, sea monsters, dogs, cats, storks, lions, tigers, frogs, deer, giraffes, and ostriches.

Photographs by Maurice Fraley

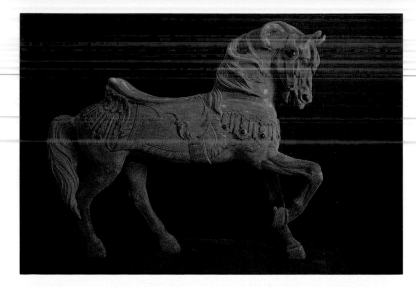

The romance or viewing side of a horse shows the flow of the mane.

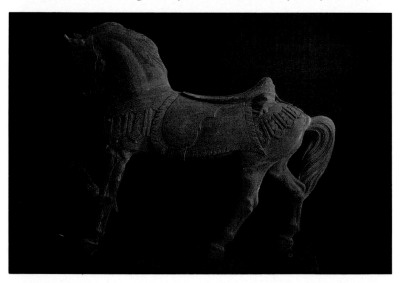

The opposite or inner side of a horse is comparatively plain.

The carousel industry began to fade away in 1920. The production of Looff's horses ceased when he died in 1918. The Mullers rejoined the Dentzel Company. Stein and Goldstein moved on to other endeavors, and Carmel's shop went out of business. Mechanical carving devices became popular with Dentzel, the Philadelphia Toboggan Company, Spillman Engineering Corporation and Allan Herschell Company. Only Illions carved by the old methods, but even he could not survive the Depression and closed in 1929. William Dentzel died in 1928; the remains of his company were bought by the Philadelphia Toboggan Company. Many of the carvers did what they could by repairing or recarving parts for operating carousels, but work was scarce. Although the Philadelphia Toboggan Company ceased making carousels in 1934, they continued building amusement park rides and are today one of the leaders in the industry.

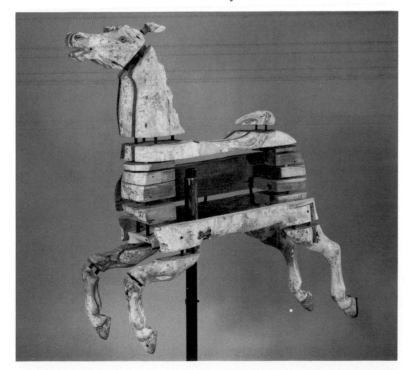

At first glance many of these richly colored figures may not appear to be made of wood at all, but rather of plastic or fiberglass. This deception is only on the surface, for stripping off the layers of paint will disclose an animal carved in hardwoods by a master craftsman. Examination of the unpainted animal will then reveal how it was assembled.

The basic contours of each animal were designed by the shop's master carver, usually the owner. The general shapes were cut out and fastened together using wooden dowels and rabbit hide glue. The body was assembled like a box, a construction which not only provided a strong base, but a much lighter and more transportable figure. Precisely fitted joints and well-defined proportions were essential before any carving could begin. The head and legs were glued and carved separately and finished before attachment to the roughed-out body of the animal. In the shops that had more than one carver, specialized craftsmen would assemble and carve only legs or bodies. The head and mane were almost always reserved for the master carver, since the positioning of the head, look of the eyes, and flow of the mane were essential in defining the animal's personality.

Once the separate pieces were assembled as a whole, finish carving took place. This task was relatively routine, although in some instances, the adjacent but distinctive styles of the mane carver and body carver would stand out from one another. It was up to the finish carver to effect a transition between the two. The result was not always successful, and examples abound where manes and bridles abruptly end.

It took approximately 40 working hours to create an average middle row jumping horse from glue-up to finish carving. Considering the complexity of the muscles, the

intricate trappings, and the grace of the mane, face and legs, 40 hours seems hardly enough time. These craftsmen were of a different age. They began to learn their craft at five years old by sweeping wood chips and sharpening tools. By the age of eighteen most apprentices could carve faster and more accurately than someone today with a shop full of electric tools.

When these animals were first constructed, their creators had little idea how they would be abused over their lifetime. To fully comprehend how carousel animals have suffered, it must be understood that their primary function was as part of a ride—a device to attract and entertain the public while making a profit for the operator. If an animal was damaged or came apart, the economics of the situation dictated that repair be as swift as possible. This led to the use of nuts and bolts, nails, screws, tin and fiberglass patches, and anything else that would hold. These types of repairs coupled with as many as ten to fifteen layers of paint gave many animals the appearance of being ready for the scrap heap.

By the late 1960's many people began to discover the rich cultural and artistic heritage embodied in the carousel. Attempts were made to restore both full operating carousels and individual animals to their original splendor. This process involved stripping the old paint, removing all foreign substances like metal or plaster, replacing missing or rotten parts, and building up worn surfaces to their original height.

Until recently, wood restoration had dealt mainly with problems related to antique furniture, so much of today's knowledge about carousel restoration was gained through experimentation. Much has been learned since the resurgence of interest first began. New methods for treating wood rot plus advances in modern adhesives and research into original painting techniques are all part of the growing fascination with these handsome figures. Community awareness and concern has prompted the rehabilitation and maintenance of many local carousels, while both private collectors and museums have painstakingly restored thousands of individual animals. This enthusiasm has come none too soon, for of the 3,000 to 4,000 wooden carousels that once graced this land, there are now fewer than 275.

Several organizations have formed over the past few years, offering information about carousel history, carving styles, and repair techniques. Please see the reference list of them on the back jacket flap. These groups give carousel enthusiasts and collectors an opportunity to restore and retain an important piece of Americana while allowing others to explore those childhood memories of riding through a world of fantasy on their favorite animal.

Carousel Horses

Throughout the history of the carousel, the horse has been and continues to be its most popular animal. When people remember riding a carousel, they almost invariably recall sitting on a horse. This is not too surprising since over eighty per cent of the animals carved in America were horses.

The following selections offer an array of carving styles ranging from the simple, interpretive horses of Armitage Herschell to the elegant and richly decorative stallions of the Dentzel Co. Since each of the over 15 companies produced animals with distinctive characteristics, there is no definitive style of carousel animal. They vary, just as the personalities of their creators did, leaving future generations with a legacy of flashing hooves and flying manes.

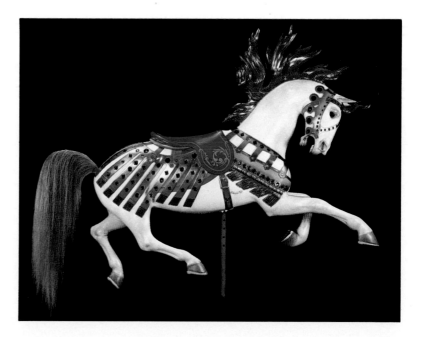

ARMITAGE HERSCHELL c. 1885

Taking their first design from Charles Dare, a manufacturer who went out of business around the turn of the century, James Armitage and Allan Herschell produced one of the simplest and most popular of the early carousel figures. Most of these early horses were exact copies of each other, varying only in the coloring of the horse and trappings. The saddle was usually a separate piece attached by several screws and was removable. This made it possible to replace the saddle which was a major area of wear. A plate printed with the maker's name is embedded in the side of this horse. The cantle bears a resemblance to a roughly carved bird.

Last Operated - Tonawanda, New York
Collection of Walt and Mary Lawrence Youree
Restored by Walt and Mary Lawrence Youree
51" long, 48" high

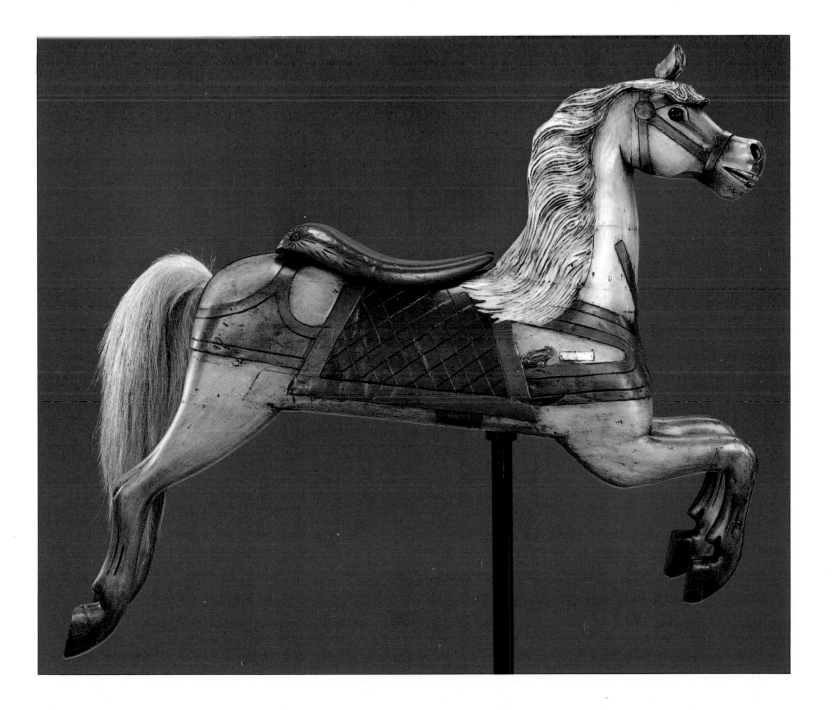

17

ALLAN HERSCHELL c. 1925

By the time the Herschell-Spillman Company formally dissolved in 1920, Allan Herschell had already been hard at work building his own company. He developed a new design, created especially for midways and carnivals. The heads and necks of his animals were large enough to be easily seen and recognized from a long distance while the legs and bodies were compact for easy transportation and set up. Despite the simplicity of Allan Herschell's horses he produced the most detailed hooves in the business, with great care given to the representation of the fetlock.

More horses were produced by the Allan Herschell Company than by any other carousel manufacturer.

Last Operated - Unknown
Collection of Janet Jones
Restored by Tobin Fraley Studios
60" long, 45 " high

18

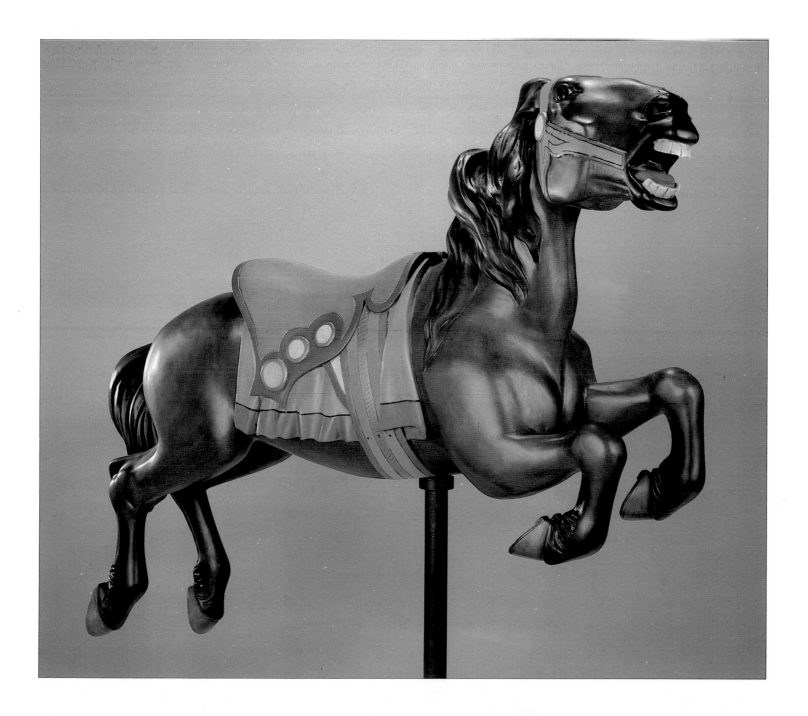

19

PARKER c. 1918

Colonel C.W. Parker used the surrounding Kansas countryside and Midwestern culture for inspiration in creating the trappings for his horses. From the factory in Leavenworth came horses with fish dangling from the cantle, bearskins for saddles, and accessories such as this dog's head cantle, and probably Parker's favorite, a cob of corn on the back of the saddle.

This horse has been stripped and left in a natural wood state. This look is very popular with some collectors, since it allows a visual understanding of the construction and carving while showing the natural beauty of the wood.

Last Operated - San Diego, California
Collection of Maurice and Nina Fraley
62" long, 32" high

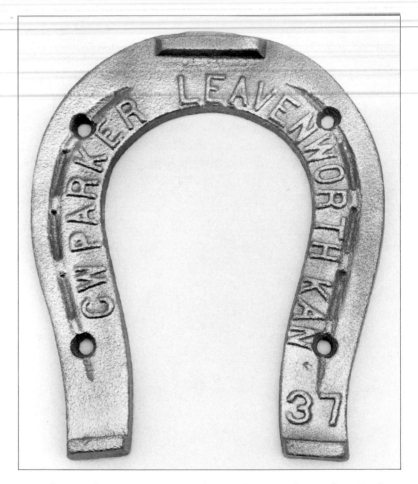

Several companies used metal horseshoes, but Parker is the only one who put his name and factory location on the bottom.

20

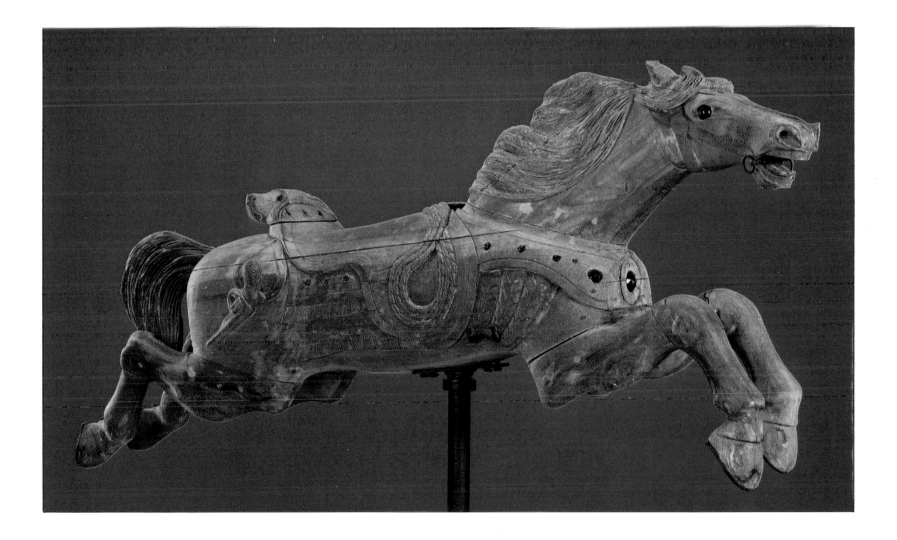

PARKER c. 1920

There was hardly a carousel produced by Parker that did not have at least one horse decorated with the stars and stripes. This was a reflection not only of Parker's strong love of country but of his moral and political convictions which were echoed in his company motto: Honesty, Cleanliness, and Morality. This horse is from one of the few permanent location machines Parker produced. An animal of this size and weight would have been very difficult to transport from town to town.

Last Operated - Happy Camp, California
Collection of Jan and Phil Herrero
Restored by Walt and Mary Lawrence Youree
78" long, 63" high

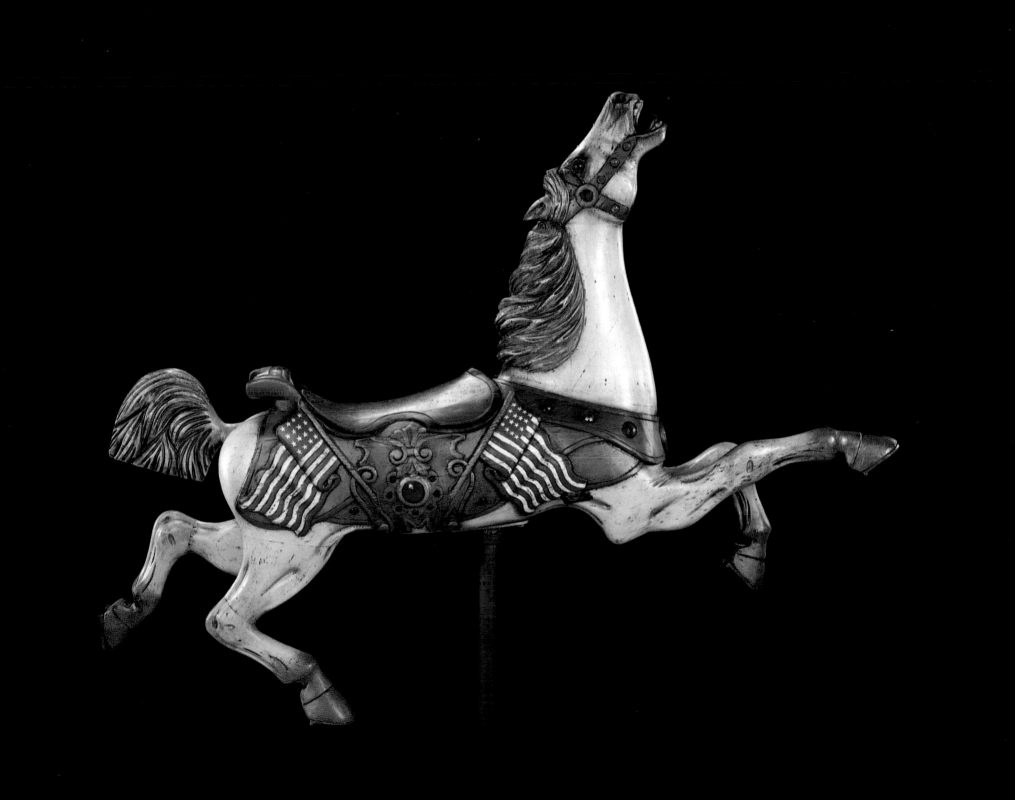

SPILLMAN c. 1921

When Alfred and E.O. Spillman reorganized in 1920 under the title of the Spillman Engineering Corporation, they relied on many of the old Herschell-Spillman Company designs. This horse shows traits later attributed to the new association—longer heads and heavier bodies —but has trappings almost identical to the flag horses produced by the Herschell-Spillman Company (1901-1920).

Last Operated - Coney Island, New York
Collection of Hoyt and Gail Griffith
Restored by Tobin Fraley Studios
52" long, 50" high

24

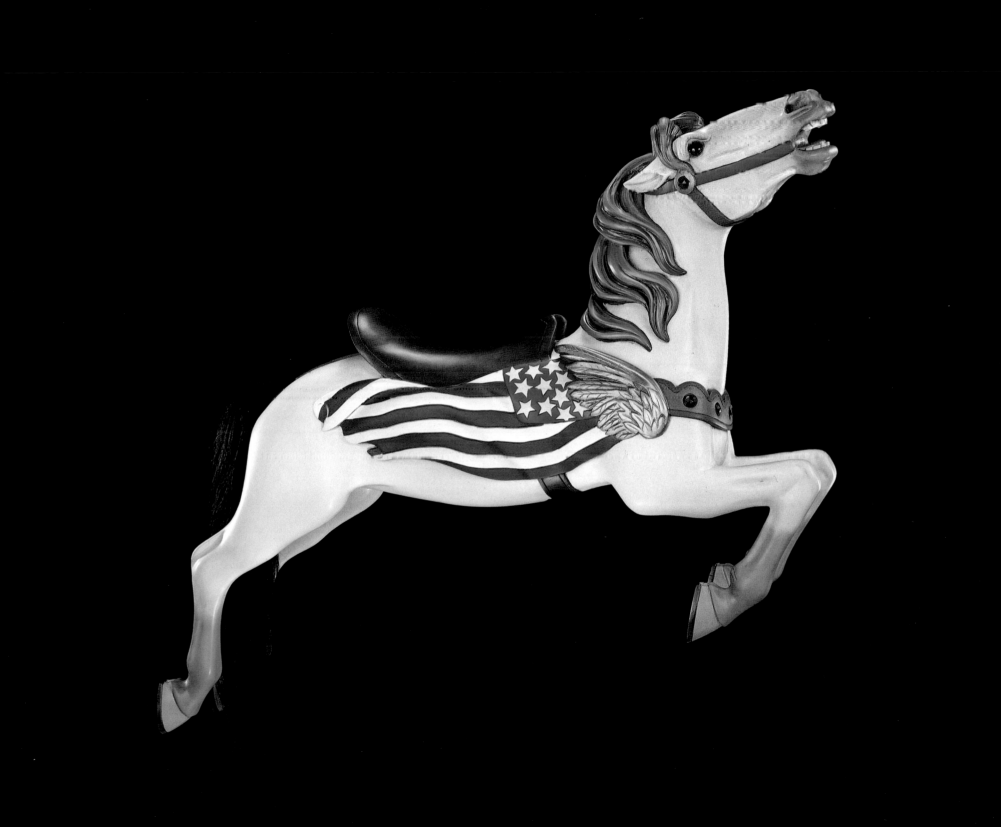

SPILLMAN c. 1924

As with Parker, the Spillman Engineering Corporation created primarily simple travelling rides, designing their animals to be easily lifted and transported, but they also built several carousels designed with a permanent location in mind. One of these was at Lincoln Park in Los Angeles, California where it burned in 1976. Fortunately, this fine example of Spillman's carving was removed before the fire.

Last Operated - Lincoln Park, Los Angeles, California
Collection of John and Jan Davis
Factory Paint
58" long, 65" high

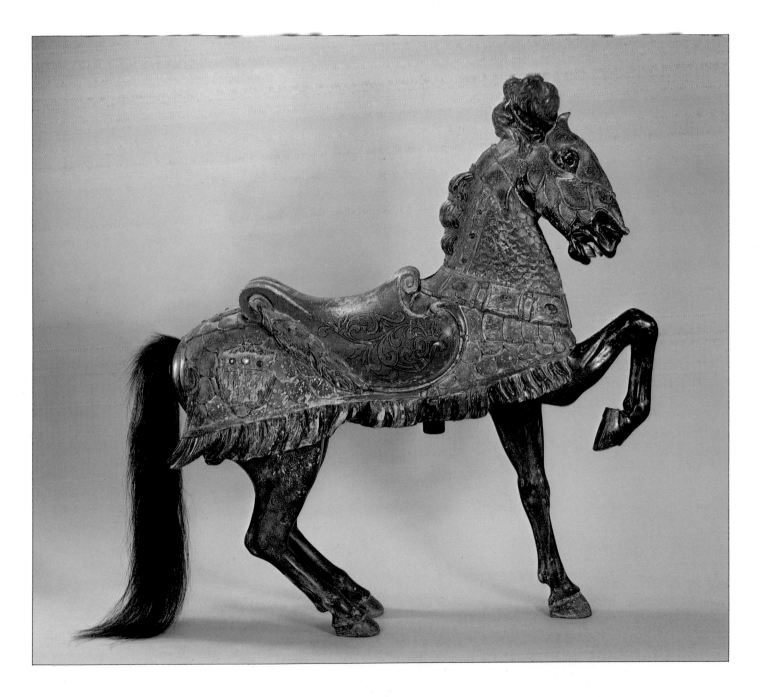

27

STEIN & GOLDSTEIN c. 1914

When Solomon Stein and Harry Goldstein formed their partnership they had a clear idea of the style they wanted to create. It was defined by long bodies with wide saddles, huge buckles, and deep relief flowers. But probably the most distinctive traits are the Roman nose and the almost Asian eyes that grace these beautiful animals. As with several other contemporaries, Stein and Goldstein used fish scale blankets, and lots of fringe.

Operating in Bushnell Park, Hartford, Connecticut
Restored by Tracey Cameron
58" long, 57" high

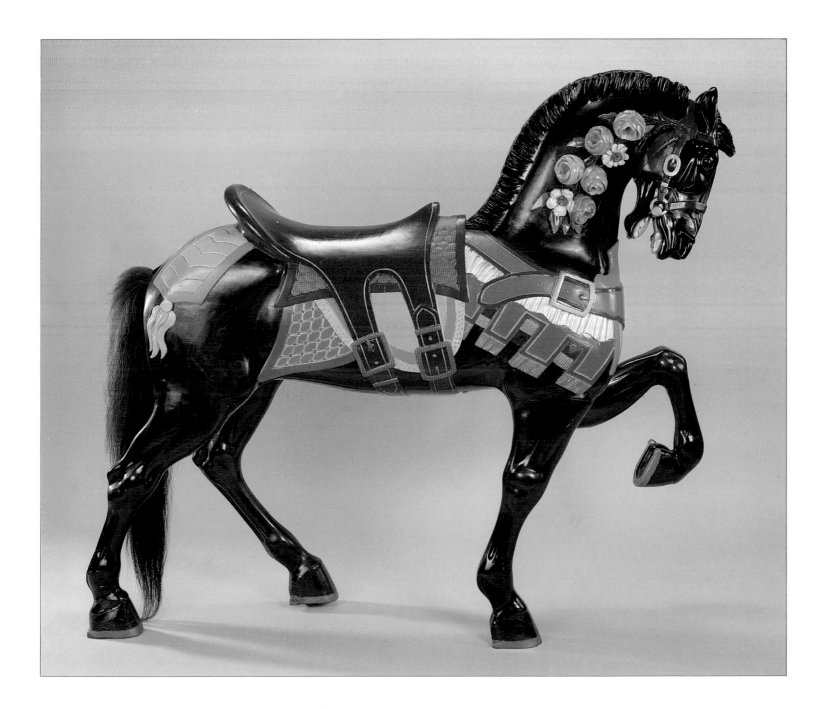

29

STEIN & GOLDSTEIN c. 1914

Stein and Goldstein were among the few carvers to own and operate most of the machines they produced. Because of this, their production was limited to only fifteen carousels between 1912 and 1925, when they turned solely to operating. Full Stein and Goldstein machines are rare today. Among those in operation are the Bushnell Park Carousel, where this flowered horse can be enjoyed and in New York's Central Park which contains some of the largest horses ever carved.

Operating in Bushnell Park, Hartford, Connecticut
Restored by Tracey Cameron
62" long, 63" high

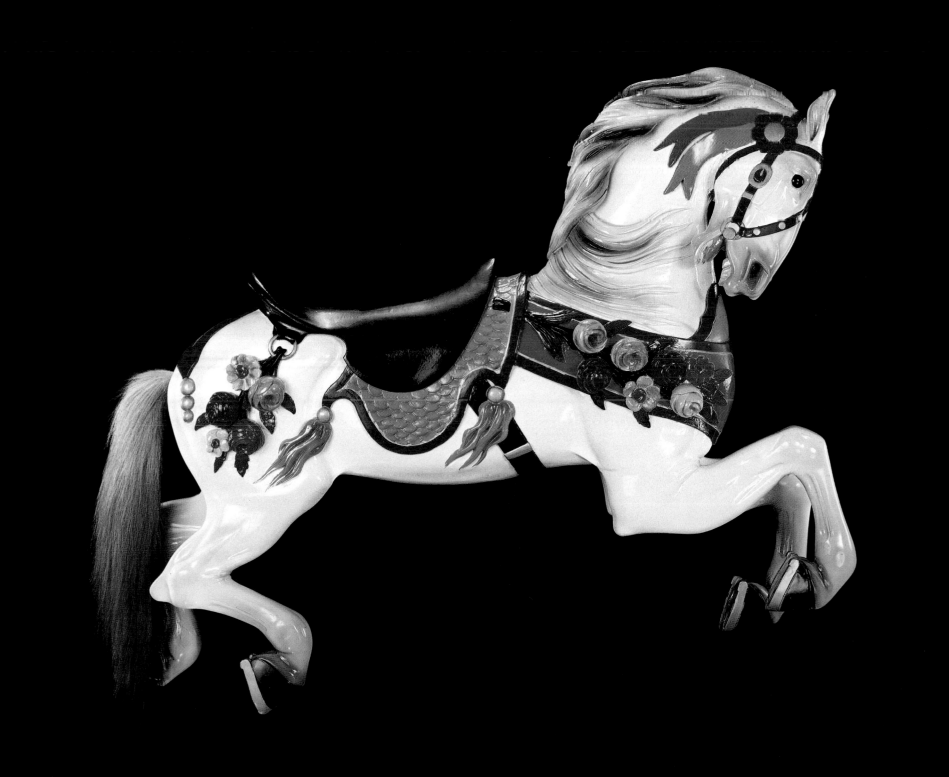

STEIN & GOLDSTEIN c. 1914

At the turn of the century medieval pageantry came into vogue, inspiring several carousel makers, including Stein and Goldstein to carve ornately armored horses. The power and grace embodied in these steeds not only made them favorites on the carousel but has made them highly prized in any collection. Their considerable value is also due to the limited number. There were at most one or two on only a few machines.

Lise Liepman, a talented painter, has incorporated metal powders with oil base paints to give the armor of this horse a very realistic look. She has also initiated a technique using tube oils to give the saddle the appearance of worn leather.

Last Operated - Woodland Park, Seattle, Washington
Collection of Richard and Christie Seeley
Restored by Tobin Fraley Studios
65" long, 68" high

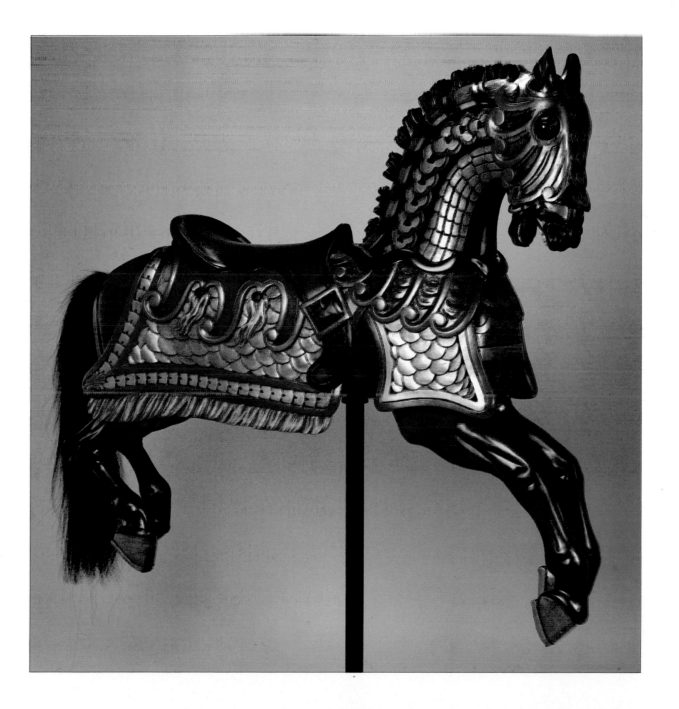

33

CARMEL c. 1914

Charles Carmel's experience with Looff and Stein & Goldstein gave him the basics in the Coney Island style of carving. When Carmel started his own shop he borrowed many decorative elements from his former employers while developing a style all his own. The feathers, fish scale blanket, bedroll, and tassels can all be found on other carver's animals, but Carmel has captured the essence of a carousel horse in the expression, proportions and flow of the mane.

Last Operated - Woodland Park, Seattle, Washington
Collection of Jane Shuttleworth
Restored by Tobin Fraley Studios
64" long, 53" high

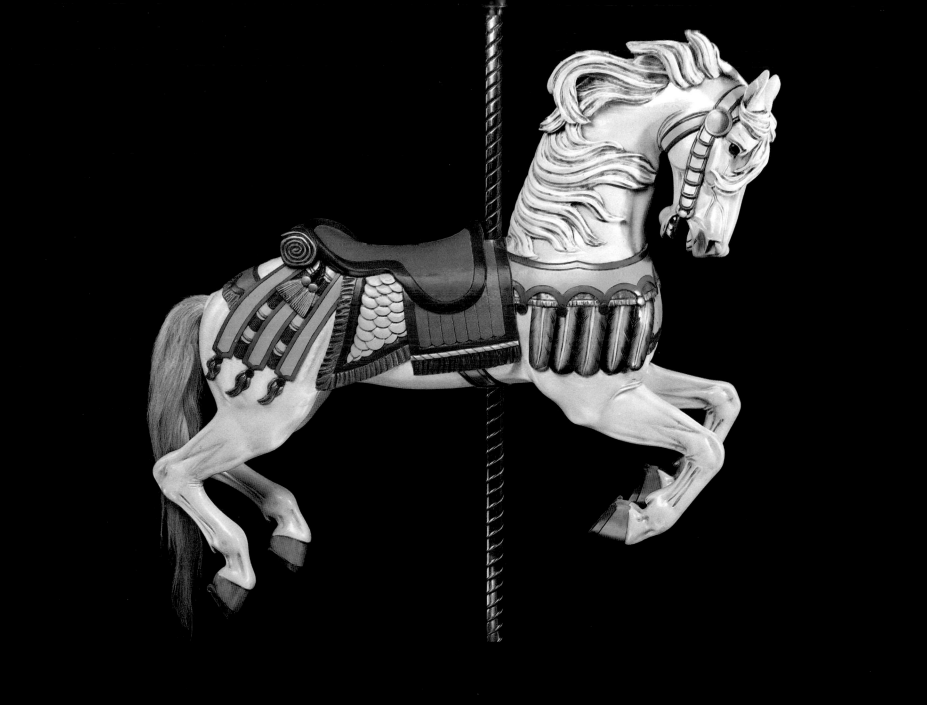

CARMEL c. 1916

Of all the Coney Island carvers, Carmel's creations were the most realistic. This may be due to the proximity of Carmel's shop to the stables of Prospect Park which offered a wide assortment of horses for models.

Unlike most of his competitors, Carmel disliked the use of glass jewels, but ironically, many of his animals fell into the hands of M.D. Borelli. Borelli was a framemaker who bought animals from Carmel, then studded each animal with hundreds of jewels, sometimes obliterating the carving.

Last Operated - Unknown
Collection of Rol and Jo Summit
Old Park Paint
57" long, 61" high

Photograph by Maurice Fraley

36

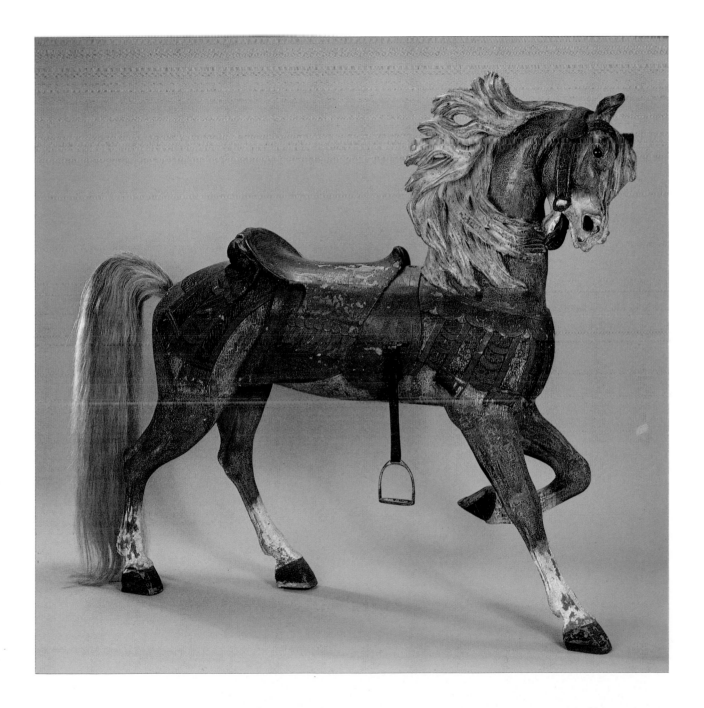

37

ILLIONS c. 1899

After carving for I.D. Looff for several years, M.C. Illions was invited to produce a carousel of his own design by framemaker William Mangels. Mangels had been contracted to reconstruct an existing Looff carousel at Feltman's at Coney Island, and since Illions had already carved several animals on the machine, he was chosen for the job. Illions' excitement and pride is quite evident in the lead horse from that machine, pictured here. The portrait on the cantle is of Illions himself.

Last Operated - Feltman's, Coney Island, New York
Collection of Rol and Jo Summit
Repaired and in Base Coat Primer
59" long, 56" high

38

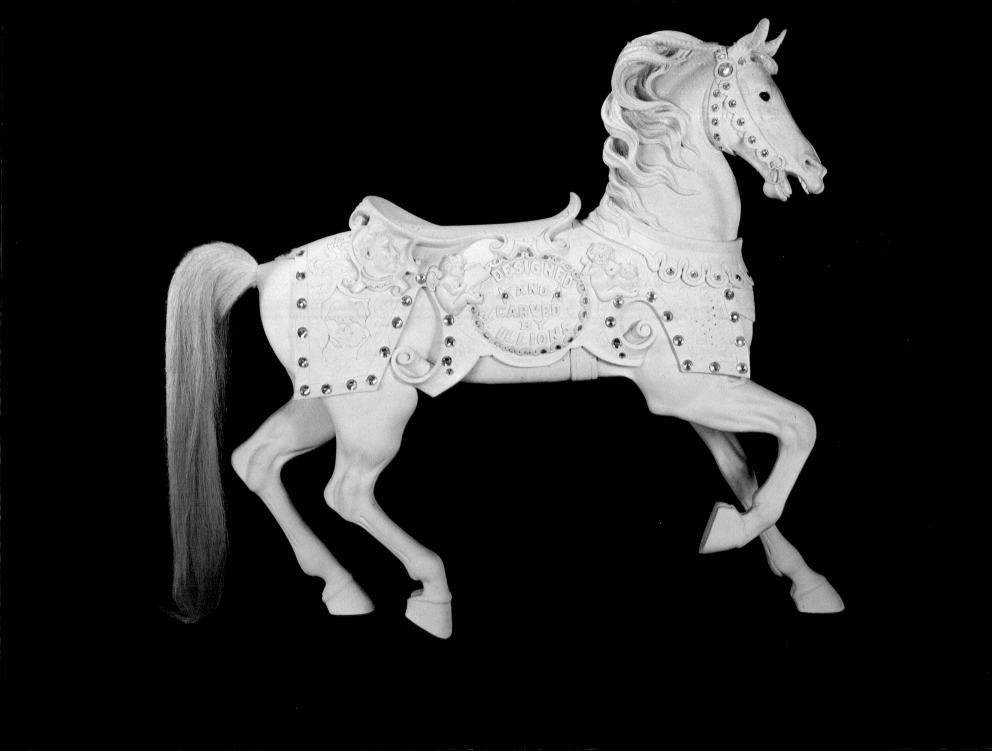

When Illions opened his own shop at Coney Island in 1909 the last bit of restraint on his imagination was removed. The manes grew wilder as the trappings became more ornate. Although Illions' work was already well known, this new freedom in design brought him and his sons more work than they could handle. This horse was painted in the original factory style in 1977, by M.C. Illions' son, Barney.

Last Operated - Stubbman Carousel,
 Coney Island, New York
Collection of Rol and Jo Summit
Painted by Barney Illions
65" long, 63" high

Drawing by Barney Illions
Photography Courtesy of
Rol and Jo Summit

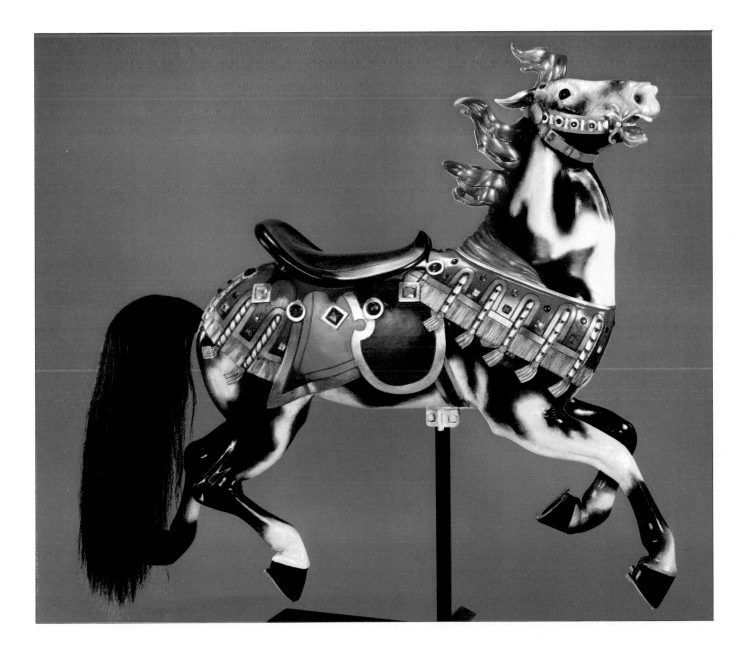

ILLIONS c. 1923

By the time this horse was carved, competition in the carousel industry had reached its peak. Many companies were switching to simpler animals and carving machines, but Illions' creative talents and belief in the traditional methods drove him to produce even more ornate horses than before. Throughout the life of the company Illions maintained strict control over quality and design. The carving of faces and manes he reserved for himself, therefore, the head was almost always the focal point of the horse.

Last Operated - Chafatino's Restaurant
Collection of Rol and Jo Summit
Restored by Rol and Jo Summit
68" long, 60" high

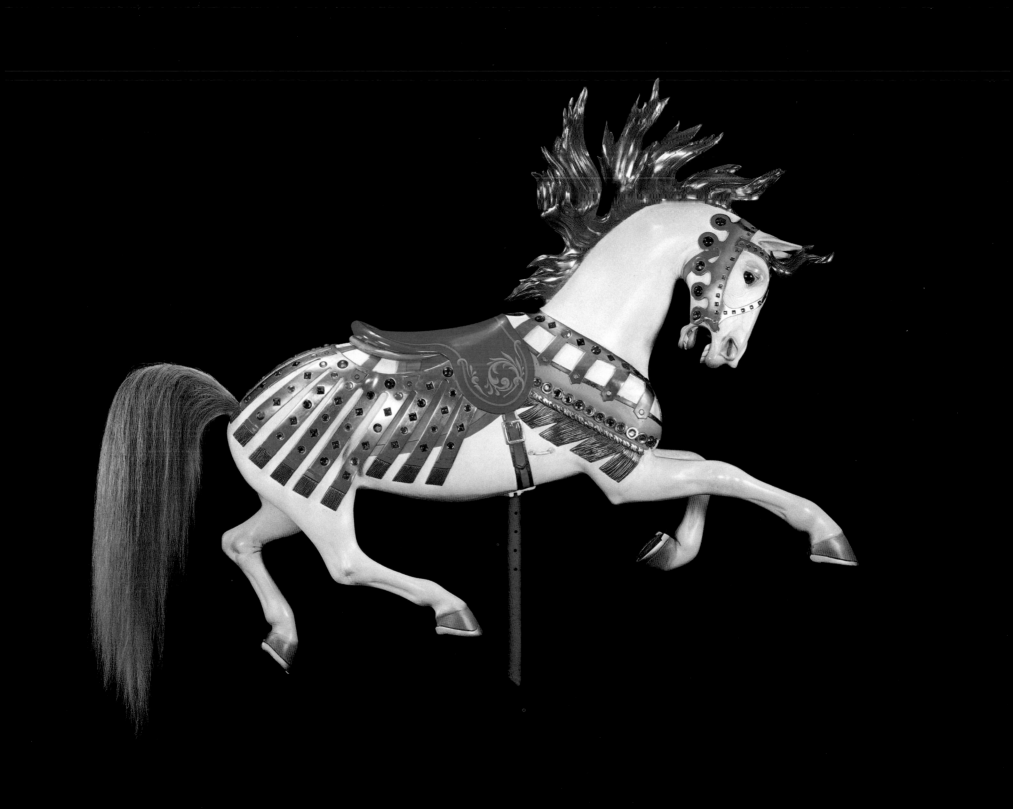

LOOFF c. 1914

Looff was one of the few carvers to portray horses with closed mouths. If they appeared at all, there would be only two to three on any one carousel. The closed mouth gives the horse a calmer, gentler look while elongating the face. About 1905 Looff started making saddles that resembled a scoop. This design left a good sized space beneath the cantle which Looff filled with a variety of gargoyles, flowers, fruit, cherub heads, and other miscellaneous carvings.

Last Operated - Sans Souci Park,
 Wilkes Barre, Pennsylvania
Collection of Tobin Fraley
Restored by Tobin Fraley Studios
50" long, 57" high

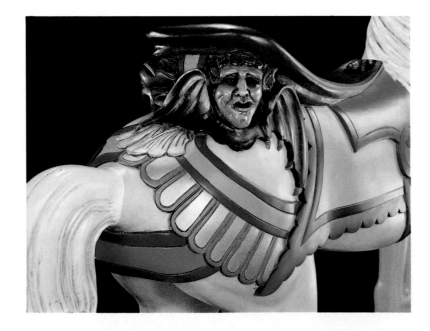

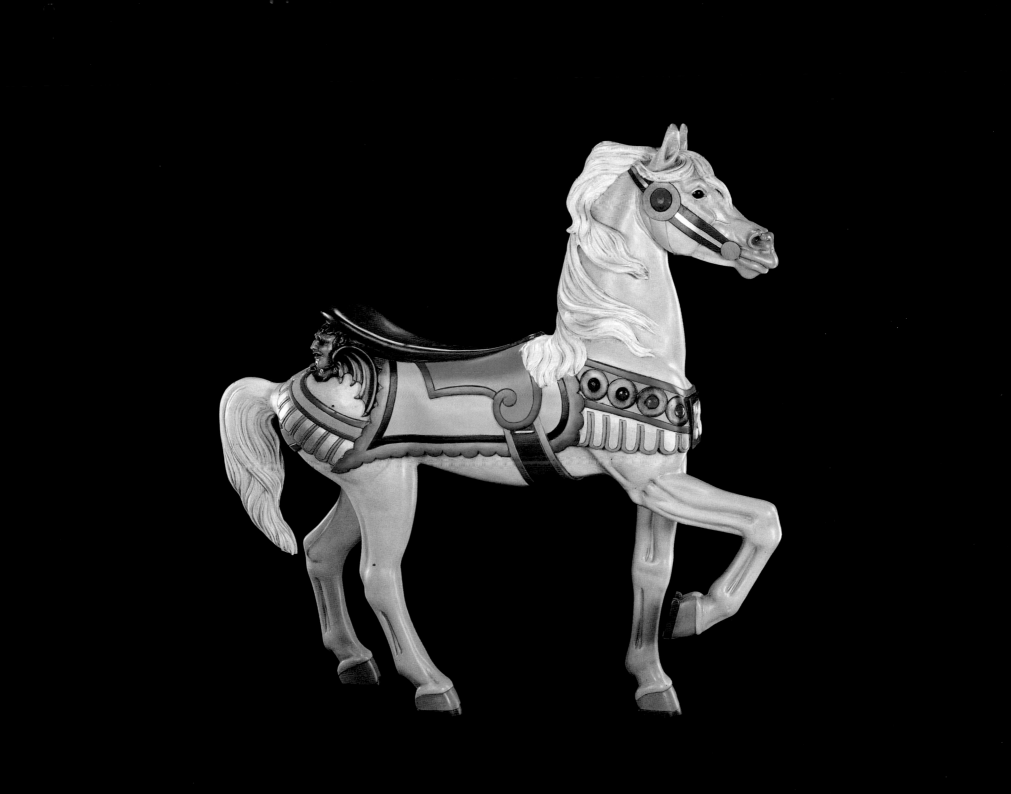

LOOFF c. 1911

Looff created armored horses in a simpler but more elegant style than his contemporaries. While Stein and Goldstein, Carmel, and Spillman were producing horses with heavy looking metal armor, Looff's horses appeared to be aspiring to more regalia by use of coats of arms and elegant drapery.

The legs of Looff's jumping horses were slender and graceful and were always portrayed with a great deal of motion. His stander's legs were usually somewhat stiff and squarish (see previous page), perhaps to give the standers more support. No other carver felt the need for such large legs.

Last Operated - Long Beach Pike, Long Beach, California
Collection of Rol and Jo Summit
Factory Paint
60" long, 58" high

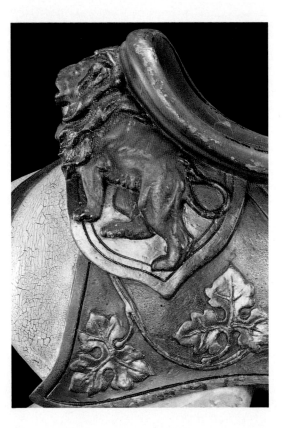

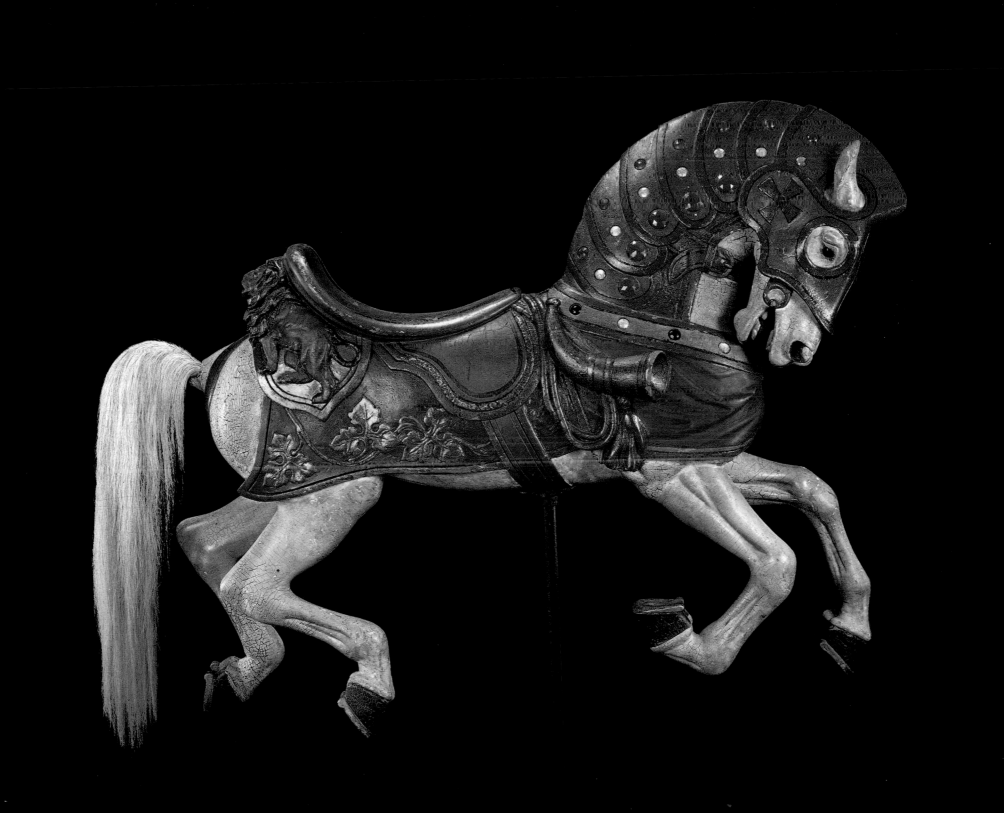

LOOFF c. 1914

In order to depict a greater sense of realism, several carvers designed manes with cut through openings, as on the horse pictured here. Although such manes produced dramatic effects, the difficulty and length of time involved in the carving process limited their use.

Wooden tails were in standard use by some companies and were optional with others. All the horses from this machine were manufactured with horsehair tails but were later returned to the factory and fitted with wooden ones. Many carousel operators liked the look of horsehair tails but found them a nuisance, since they were constantly being pulled out or cut off.

Last Operated - Sans Souci Park,
 Wilkes Barre, Pennsylvania
Collection of Gary and Bonnie Wolf
Restored by Maurice and Nina Fraley
57" long, 49" high

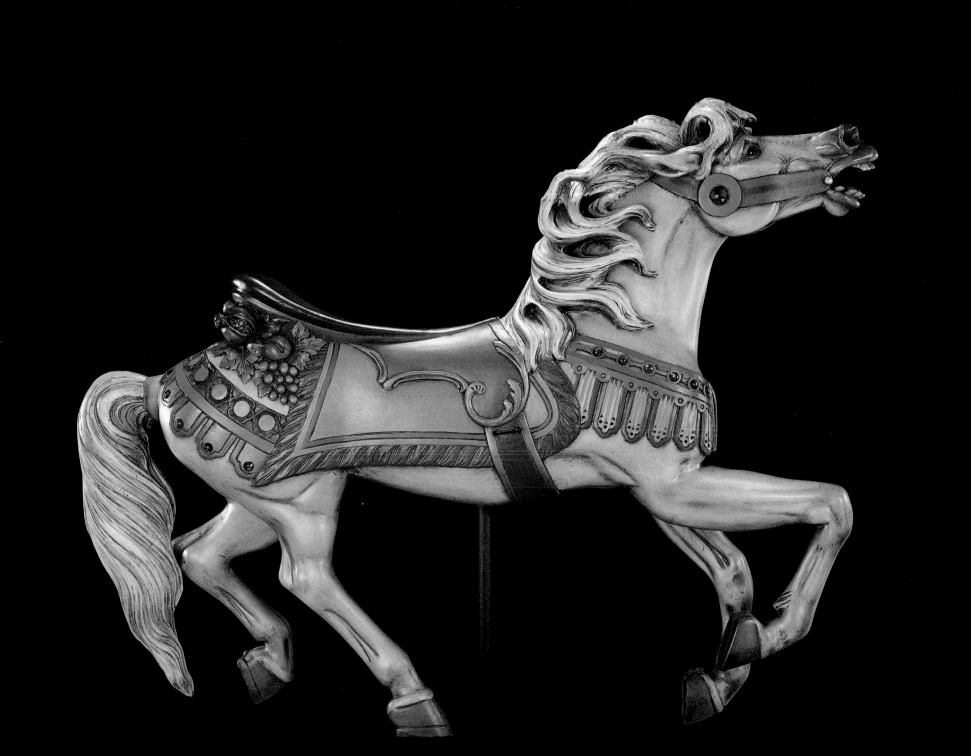

PHILADELPHIA TOBOGGAN COMPANY *c. 1922*

The Philadelphia Toboggan Company based the
design of their many armored horses on medieval
pageantry but they would usually take the liberty of
artistic embellishment. Unlike the realistic armor of Stein
and Goldstein, PTC created fanciful armored horses and
made the flow of the trappings a primary concern. This
style of carving led to horses such as this one that have
an almost dreamlike quality.

Operating at the Santa Monica Pier,
 Santa Monica, California
Restored by Tracey Cameron
59" long, 58" high

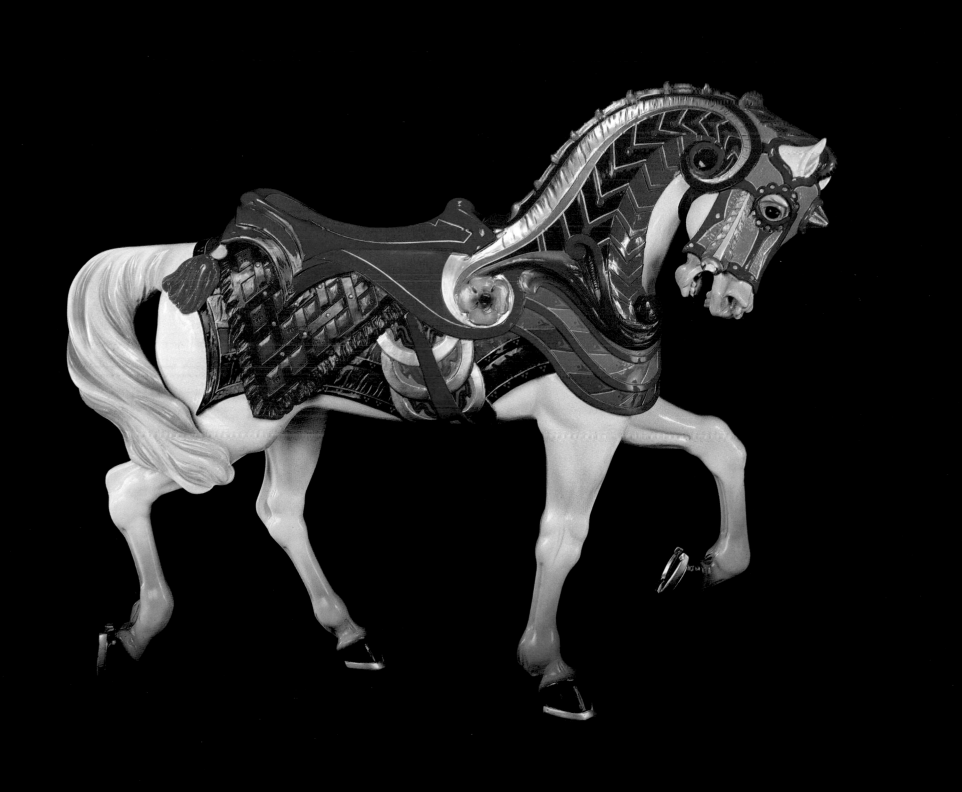

PHILADELPHIA TOBOGGAN COMPANY *c. 1918*

When the Philadelphia Toboggan Company first started producing carousels in 1903, the trappings were quite simple with fancy details restricted to the back of the cantle. By 1918 when this horse from carousel #45 was produced, the carvers' imaginations were no longer reserved. PTC master carver John Zalar was responsible for some of the most extravagant trappings ever designed; his influence is felt in the abundant decoration of this horse. Such profusion of carving was to continue until 1934 when PTC ceased making new carousels.

The location plate appears on the bridle of this horse on the non-romance side.

Operating at Marriot's Great America,
 Santa Clara, California
Park Paint
59" long, 50" high

52

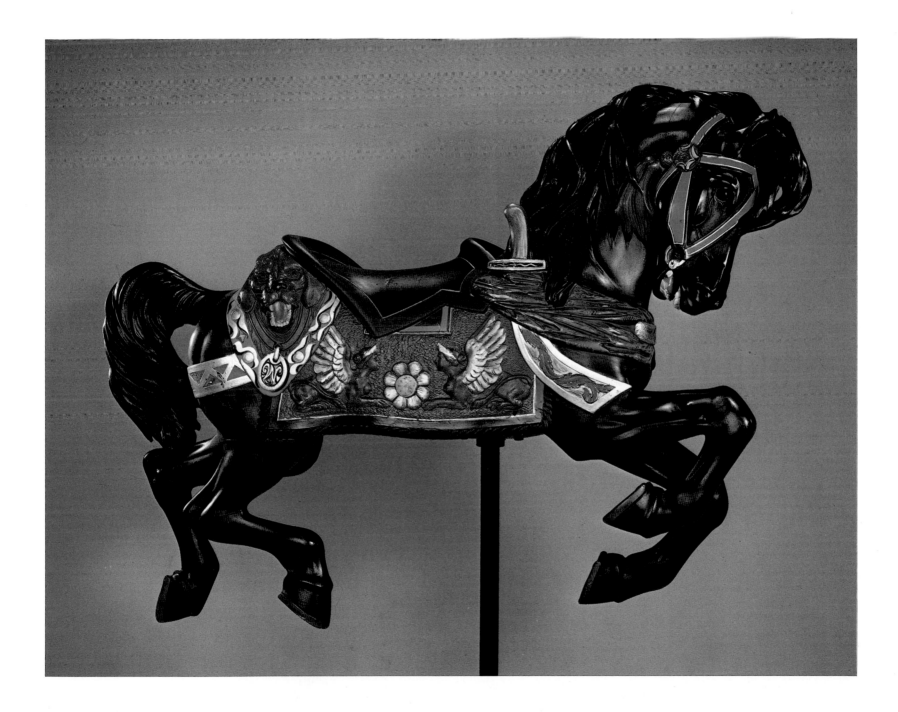

PHILADELPHIA TOBOGGAN COMPANY *c. 1918*

Drawing on cultures from around the world, the Philadelphia Toboggan Company created trappings for horses with a sense of magic. Depending on which horse children chose to ride, they could be transported to the Middle East, the Midwest or the Middle Ages. Fantasy was the keynote.

The pegs on the bottom of the hooves fit into slots in the carousel platform giving the horse added stability.

Operating on Philadelphia Toboggan Company
 Machine #45,
Marriott's Great America, Santa Clara, California
Park Paint
60" long, 60" high

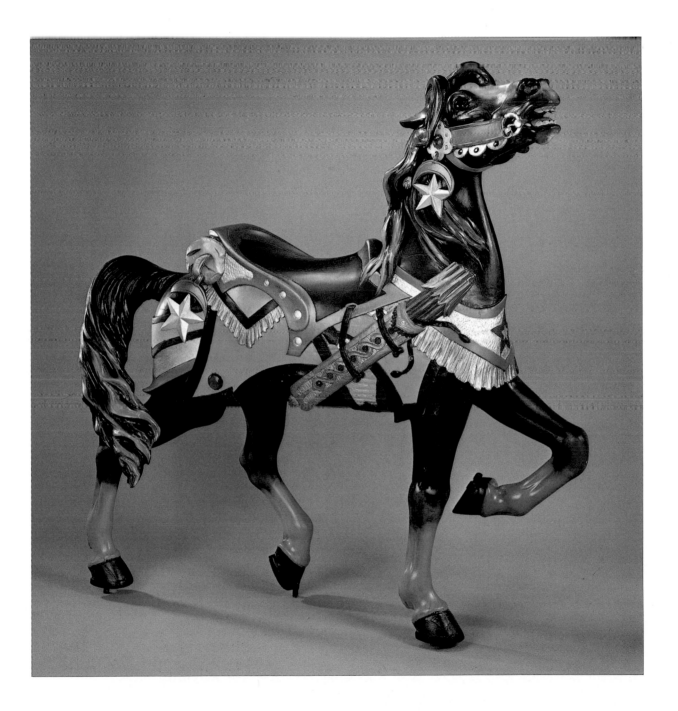

MULLER c. 1905

Daniel Muller's artistic talents and craftsmanship are not only recognized and appreciated by carousel connoisseurs today but were equally appreciated by his contemporaries within the carousel industry. When asked about his co-worker, Salvatore Cernigliaro commented, "Now Daniel Muller, there was a true artist." This was high praise coming from a man who produced some of the most detailed and delicate figures to ever adorn the sides of carousel animals.

This horse was carved at a time when Muller's own style was beginning to emerge. It comes from one of the first Muller carousels and is stylistically between the Dentzel horses of 1900 and the horse produced by Muller in 1910, pictured on the following page.

Last Operated - Unknown
Collection of Rol and Jo Summit
Restored by Rol and Jo Summit
60" long, 58" high

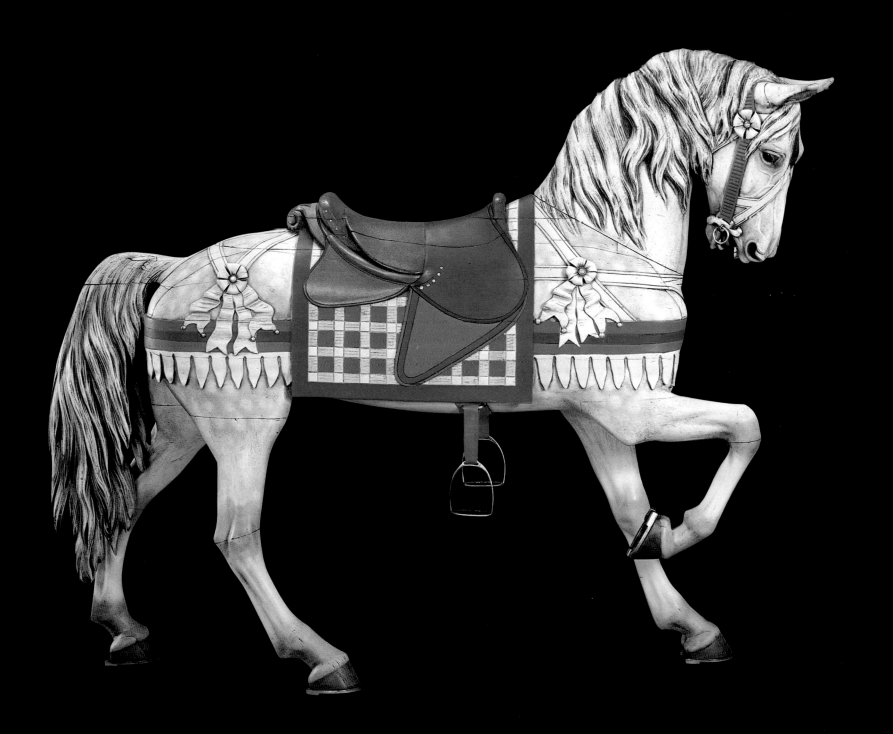

MULLER c. 1910

By the time this horse was carved, Muller had developed his own distinctive style. The face, although squarish in design, is extremely expressive and the neck, chest and thighs are quite muscular giving the horse a very powerful look. The horse pictured here has trappings fashioned after those found on circus horses, but the saddle is modeled after the 1859 McClelland military saddle. Muller was the only carver of the Philadelphia or Coney Island styles to use metal horseshoes.

Last Operated - Benit Amusement Park, Arnolds Park, Iowa
Collection of Hoyt and Gail Griffith
Restored by Tobin Fraley Studios
59" long, 63" high

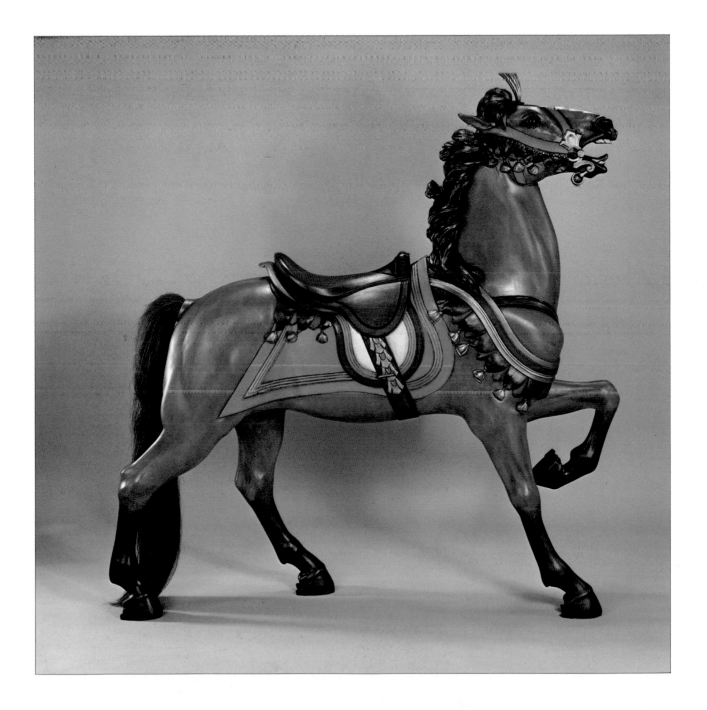

59

MULLER c. 1924

When Daniel Muller broke from the Dentzel Company and started his own business in 1905, he turned to the Civil War for thematic inspiration. Using Arabian horses for his models and paying close attention to detail, Muller carved some of the most strikingly beautiful horses ever produced. After rejoining the Dentzel Company in 1918 he was allowed to use his own designs in the creation of several distinctive Muller carousels.

Last Operated - Unknown
Collection of Freels Foundation
Original Paint
60" long, 62" high

The Muller designed carousel on page two is from the Dentzel factory. Photograph courtesy of Mike Roberts.

60

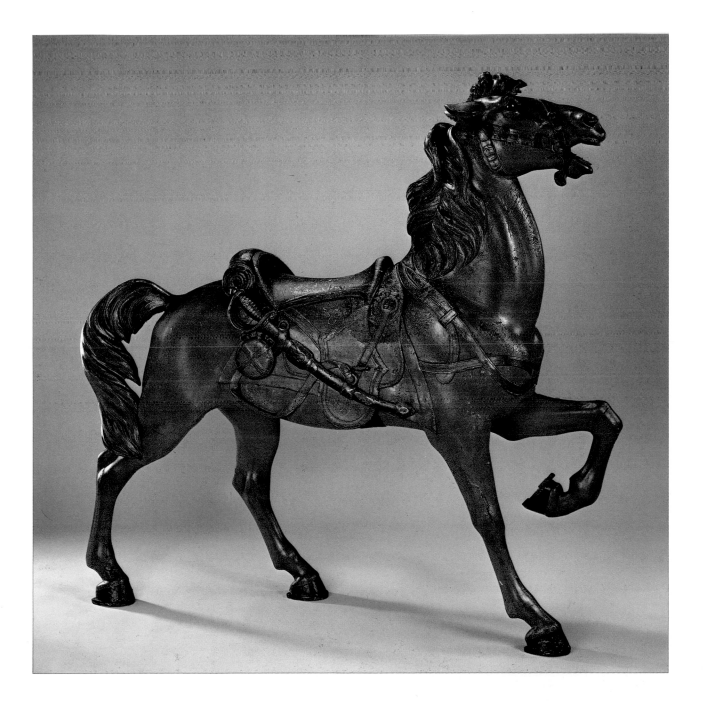

61

DENTZEL c. 1895

 This Dentzel stander has been painstakingly stripped down to the original paint, exposing not only the meticulous dappling job but also the delicate striping on the saddle blanket which accented most Dentzel animals as they came out of the factory.

 This horse represents a transition period in the Dentzel Company. The pose and face are similar to the style generally accepted as being from Dentzel after 1900 while the mane and trappings are typical of the style before 1895. The use of glass jewels by Dentzel was limited; those pictured here are held on by metal frames which are tacked on to the horse with small nails.

Last Operated - Unknown
Collection of Marge Swenson
Original Paint
65" long, 58" high

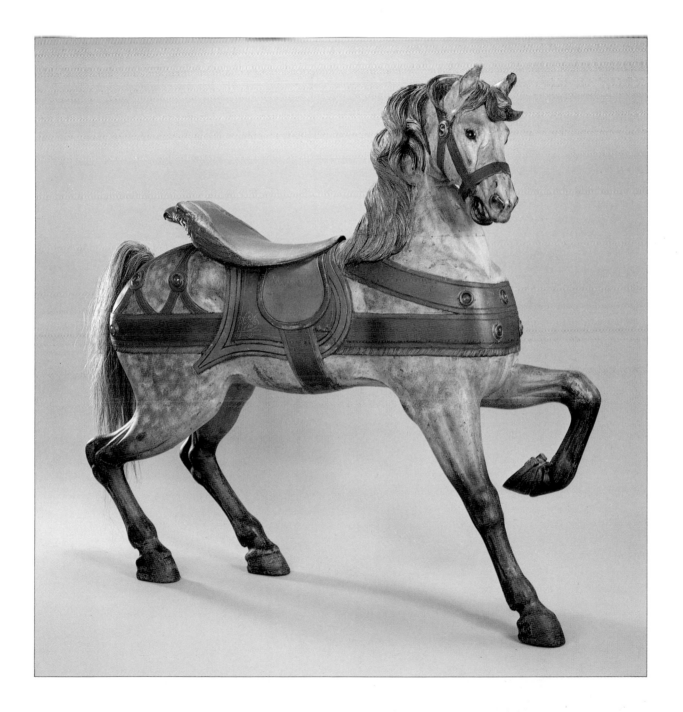

63

DENTZEL c. 1910

In 1903 Salvatore Cernigliaro, a furniture carver who had recently arrived from Italy, joined the Dentzel staff. His style of carving was so original and provocative that Gustav Dentzel gave him a free rein in design. The factory was soon turning out animals with flowing drapery and beautifully crafted, delicate figures clinging to the trappings. This angel is a fine example of Cernigliaro's work, and these figures are affectionately referred to as "Cherni figures" by the carousel world.

Last Operated - Edgewater Park, Dearborn, Michigan
Collection of the Freels Foundation
Restored by Maurice and Nina Fraley
62" long, 60" high

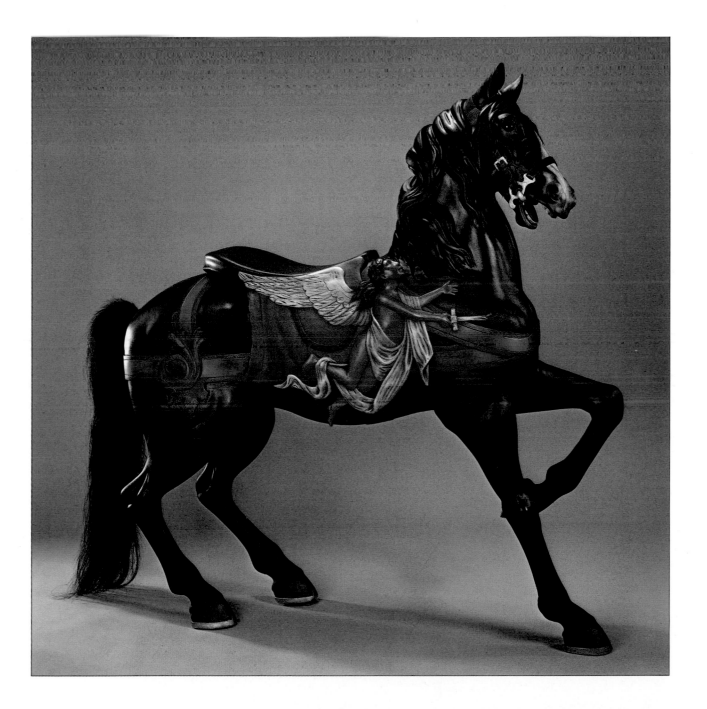

65

DENTZEL c. 1905

 This horse epitomizes the Dentzel style at the height
of its elegance. The Cherni figure graces the side while
a delicately carved bridle passes through a cropped or
roached mane, similar to those found on many of Dentzel's
horses. The eagle back saddle rests atop a finely muscled
animal; unique elaborate trappings wrap the front
and back.
 Muller left the Dentzel Company soon after this
horse was carved. A few years later Gustav Dentzel died.
Although his son, William, ran the business well, the
detail and artistry was never to reach the stature of
the past.

Last Operated - Playland Amusement Park,
 Seattle, Washington
Collection of the Freels Foundation
Restored by Maurice and Nina Fraley
63" long, 59" high

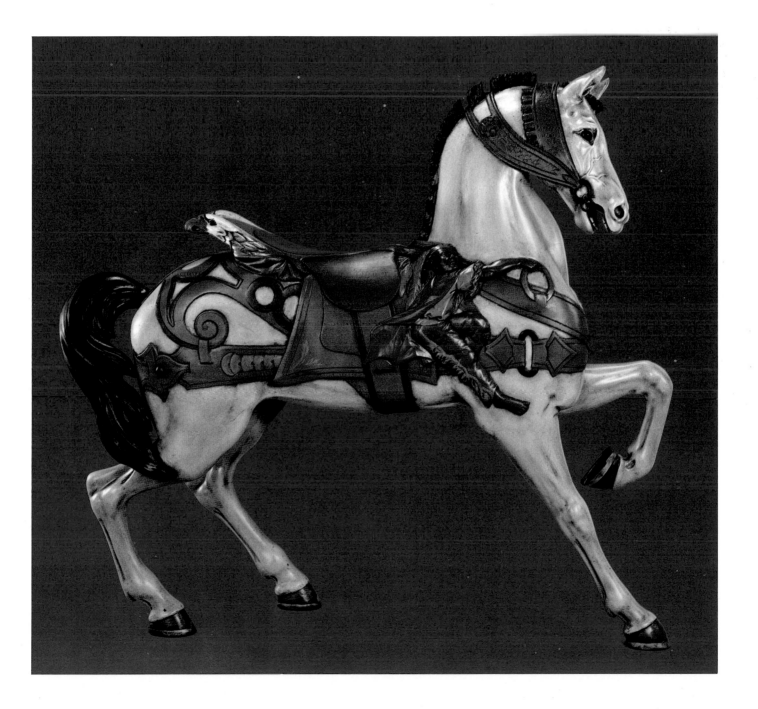

Menagerie Animals

Animals other than horses first appeared on carousels in the late 18th century, but it wasn't until Charles Looff introduced an assortment of creatures on his first carousel in 1876 that these figures began to be popular. During the same period Frederick Savage began filling his roundabouts with galloping chickens and flying pigs. Soon carousels throughout both Europe and America had a variety of animals leaping among the horses.

Despite Looff's early start, the two companies which were to become best known in this field were Dentzel and Herschell-Spillman. Dentzel created very realistic and intricately carved animals, sometimes captured in dramatic poses, while Herschell-Spillman is noted for a wide variety of animals, ranging from frogs, to storks, to zebras.

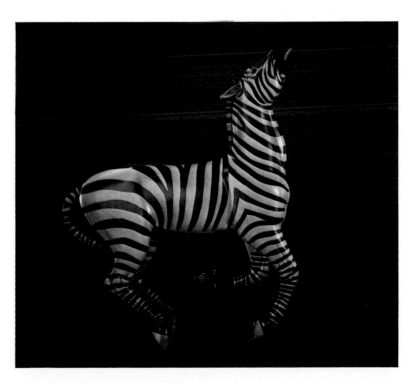

HERSCHELL-SPILLMAN FROG c. 1915

Not only is the Herschell-Spillman Company the only carousel manufacturer to produce a frog, but the frog is the only American carousel animal known to be wearing human apparel. The inspiration for this outfit may perhaps be traced to Kenneth Graham's 1908 classic, *The Wind in the Willows*, wherein Mr. Toad dons similar attire before taking a drive in his motor car.

This frog is in factory paint with his original vest buttons still intact. The opposite side of the vest has carved buttonholes.

Last Operated - Unknown
Collection of Gary and Bonnie Wolf
Factory Paint
38" high, 42" long

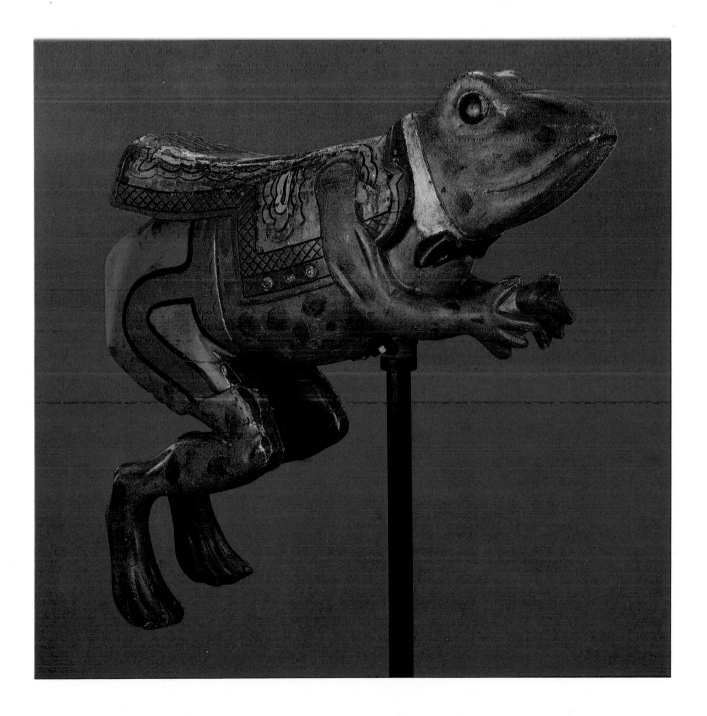

71

DENTZEL OSTRICH c. 1910

Dentzel added this relatively unknown bird to his collection of menagerie animals around 1900. His inspiration may have come from the travelling Sells-Floto Circus which came through Philadelphia in 1899. As many as four ostriches would appear on a full menagerie carousel, riding two by two on opposite sides of the machine.

Last Operated - Edgewater Park, Dearborn, Michigan
Collection of Freels Foundation
Restored by Maurice and Nina Fraley
49" long, 58" high

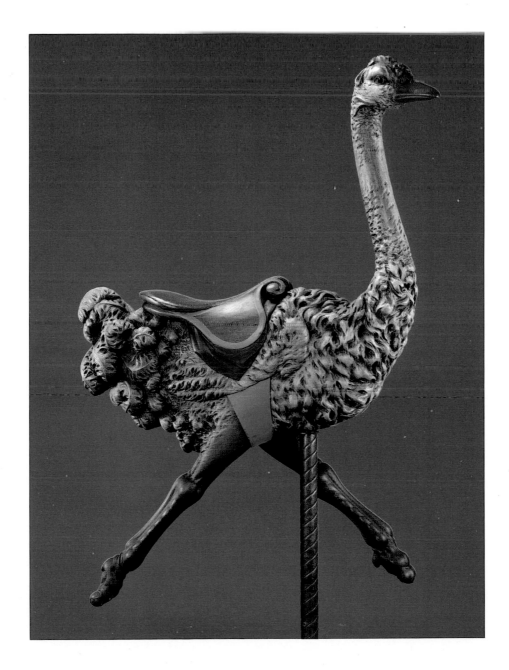

73

HERSCHELL-SPILLMAN STORK c. 1912

Most of the folklore represented on carousels received a personal interpretation by the carver. While cherubs and demonic figures were commonly used as decorations, contemporary folk heroes and U.S. presidents also graced the trappings. This bird, however, derives its theme straight from the popular folk story about the stork that delivers babies. Over six feet tall and walking with a purposeful stride, this stork was restored in 1978.

Operating on the Tilden Park Carousel, Berkeley, California
Restored by the Redbug Workshop
54″ long, 72″ high

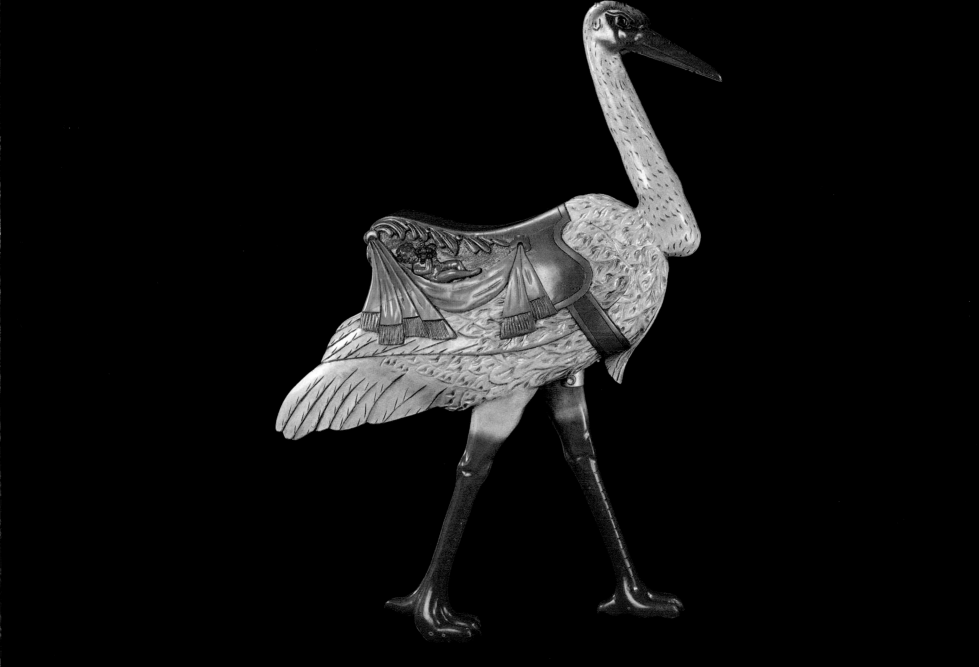

DENTZEL ROOSTER *c. 1895*

Several companies produced roosters, but Dentzel's representation was by far the most intricate and realistic. The time-consuming detail work involved in carving the rooster may have led to its demise and replacement by simpler animals. No Dentzel roosters were carved after 1900 and only five are known to exist today. This bird took his last ride at Neptune Beach in Alameda, California and was later put into storage where its paint was scorched by a fire. It was restored in 1972.

Last Operated - Neptune Beach, Alameda, California
Collection of Maurice and Nina Fraley
Restored by Maurice and Nina Fraley
55" long, 50" high

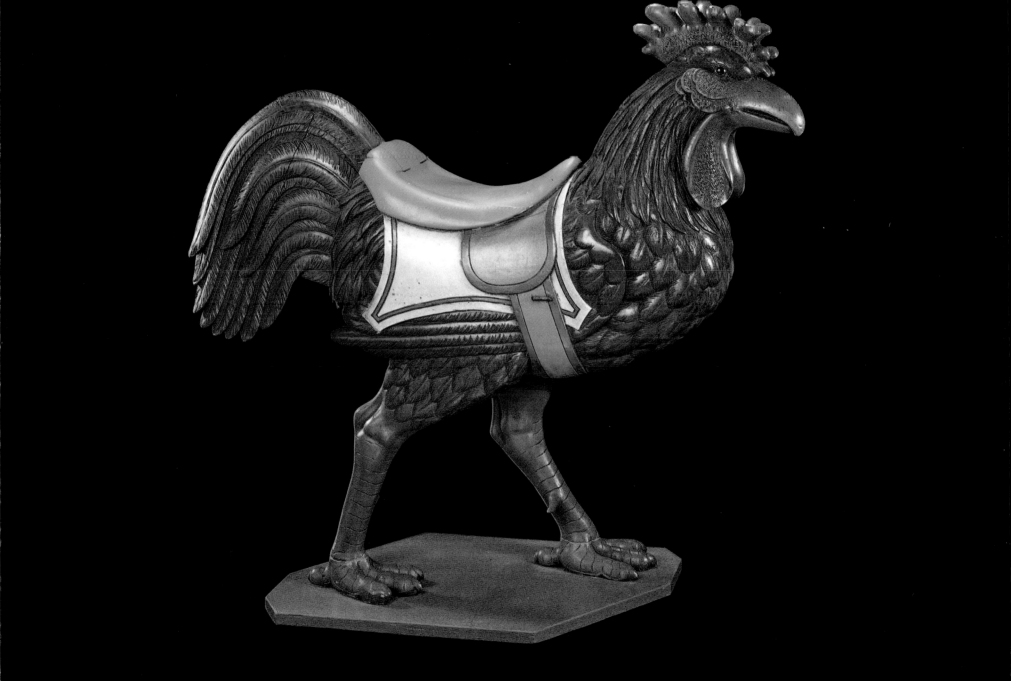

DENTZEL RABBIT *c. 1908*

Several types of Dentzel's menagerie animals, including rabbits, were always carved as jumpers. Dentzel machines carried only standers on the outside row which meant that these animals were relegated to the inner rows, thus obscuring their sides from direct public view. Because of this, few of these jumpers were carved with more than standard trappings. This rabbit is one of the exceptions, carrying this ribbon and moon carved by Salvatore Cernigliaro.

Last Operated - Unknown
Collection of Bill and Marion Dentzel
Restored by Maurice and Nina Fraley
60" high, 50" long

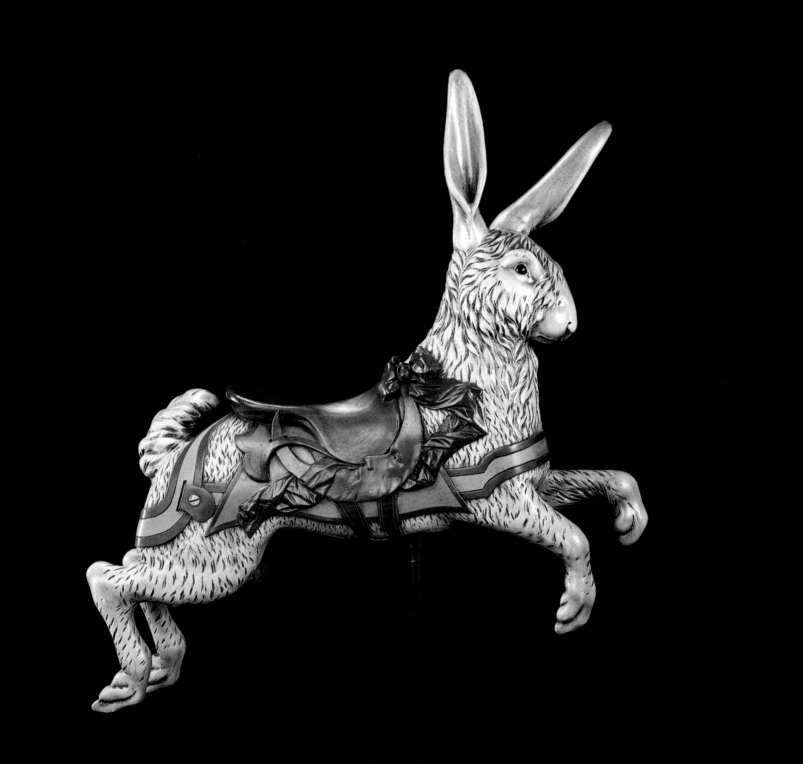

DENTZEL BEAR c. 1904

First introduced by Dentzel around 1900 the carousel bear never gained the popularity of many of the other menagerie animals. Despite this slow start, the Dentzel bear has become one of the most sought after by collectors, due to both its rarity and its friendly expression.

Last Operated - Grants Park, Atlanta, Georgia
Collection of Rich Thomas and Lise Liepman
38" long, 38" high

80

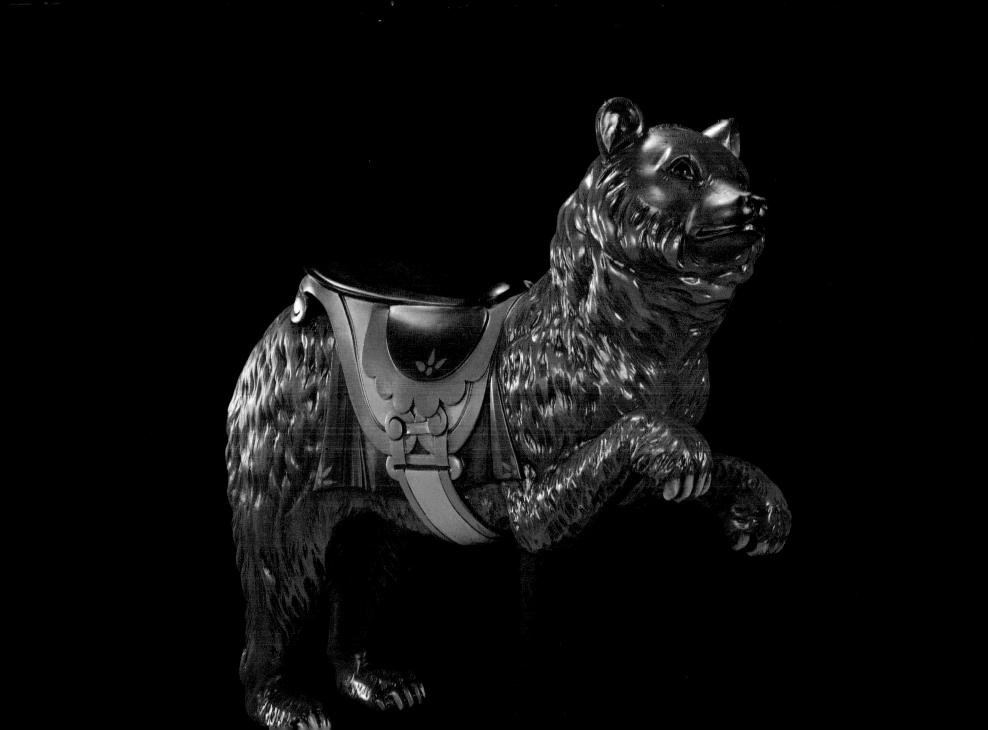

DENTZEL LION c. 1905

The lion was among the first of the menagerie figures
to appear on carousels, showing up on European
machines as early as 1837. Although most of the companies
produced lions, Dentzel's rendition is considered to be
the finest. The strong muscular tones, elegant trappings
and proud pose all lend themselves to that grand
reputation. Originally placed in Idora Park in Oakland,
California, this lion also rode at the Treasure Island
World's Fair in 1939.

Last Operated - Playland Amusement Park,
 Seattle, Washington
Collection of Tobin Fraley
78" long, 55" high

Photograph by John Berg

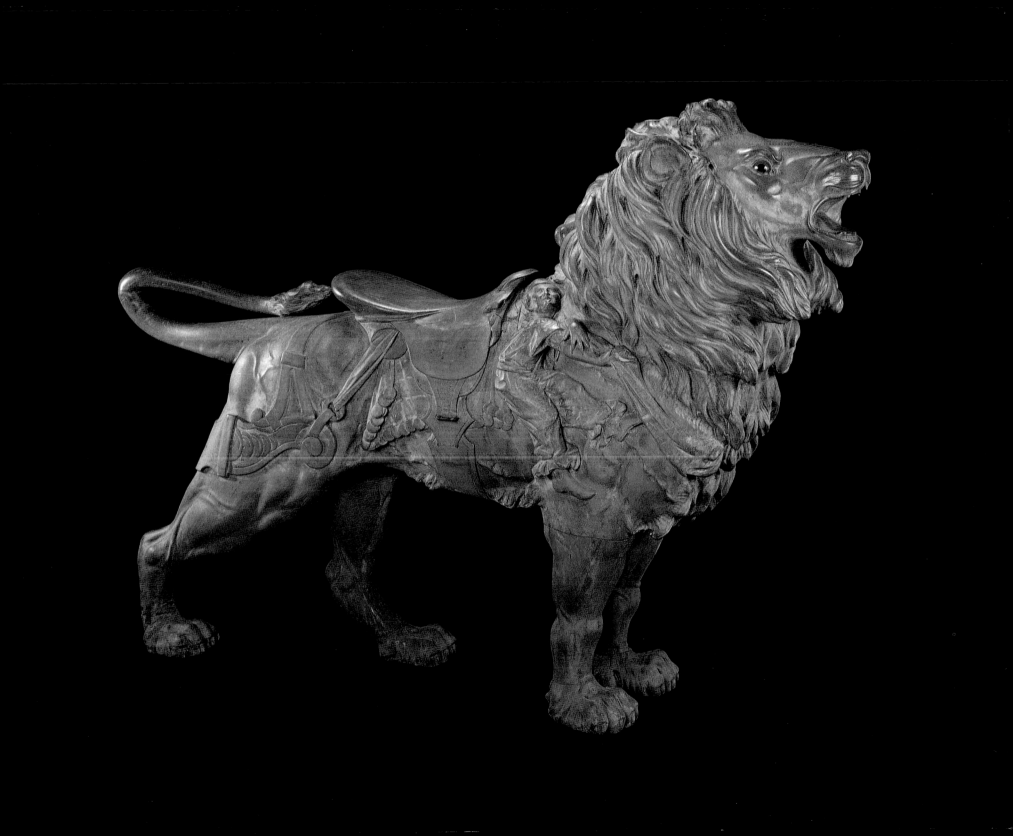

DENTZEL TIGER c. 1910

Appearing only once on any given carousel, both the lion and tiger are quite popular with riders and collectors. Although not as detailed as the lion, the tiger is no less imposing a figure. Teddy Roosevelt charging up San Juan Hill is depicted in this unusual display of contemporary folklore.

When animals such as this tiger were first painted, lead base paints were in regular use. These paints covered the animal in only one coat and blended with each other quite well, unfortunately they were also quite toxic. The paints used during the restoration of this animal were tube oils and have been painstakingly applied in order to enhance the beauty of the original carving.

Last Operated - Edgewater Park, Dearborn, Michigan
Collection of the Freels Foundation
Restored by Maurice and Nina Fraley
63" long, 53" high

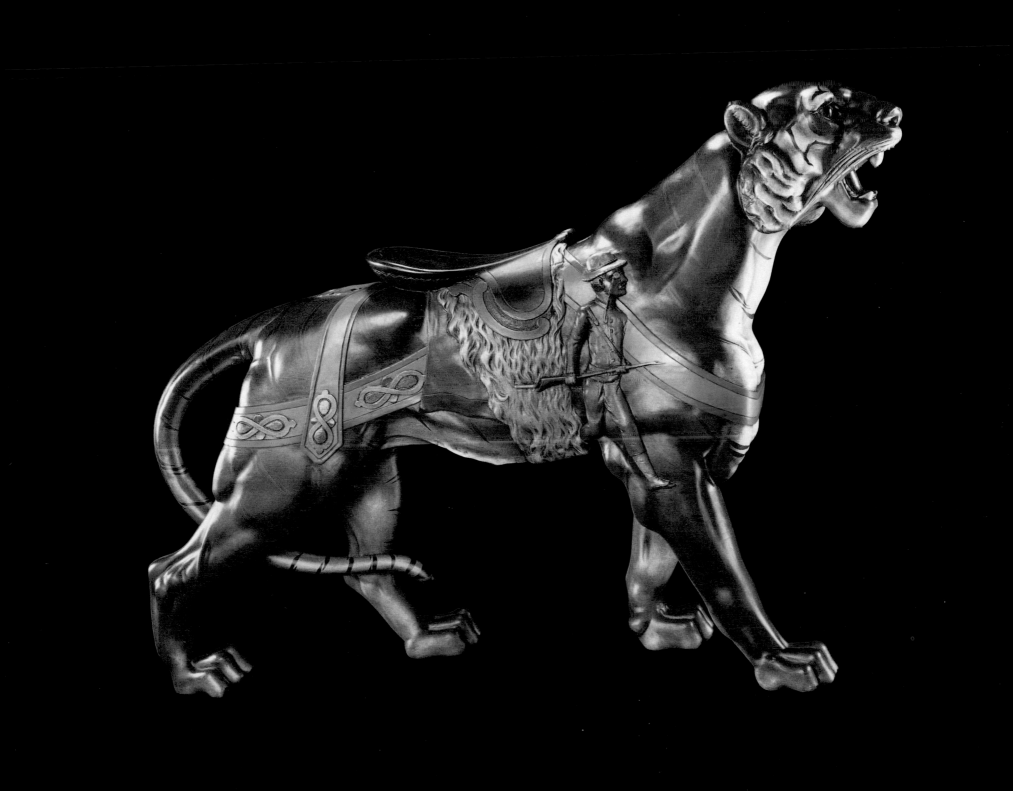

LOOFF CAMEL c. 1917

The camel was among the animals Looff carved for
his first carousel in 1875 and of those animals was the
only one to remain a standard menagerie figure throughout
his career. He was always refining his designs, so that
by the time this camel was carved he had captured its
essence. The jewels, the factory paint of gold, deep reds
and oranges, and the magical gaze of the monkey combine
to give the rider a sense of having stepped back into the
Arabian nights.

Last Operated - Long Beach Pier, Long Beach, California
Collection of John and Jan Davis
Factory Paint
57" long, 56" high

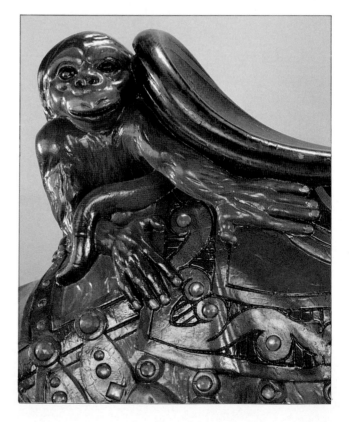

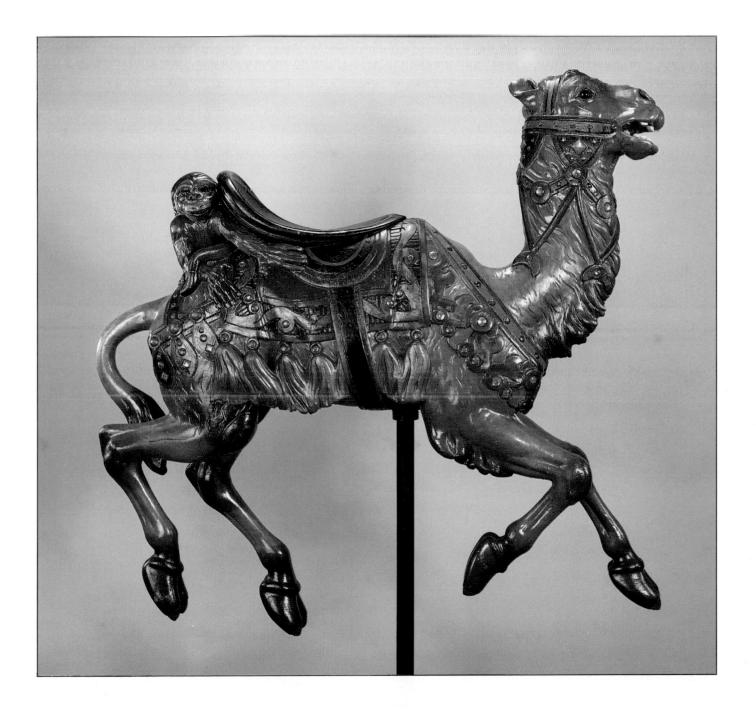

DENTZEL DEER c. 1920

Of all of Dentzel's menagerie figures the deer was carved most often. Although this popularity was partially due to the familiarity of the deer to American children, much of the deer's appeal comes from its gentle nature. This prancing buck is typical of the Dentzel style of deer. Several of Dentzel's carousels contain deer as the only animals aside from the horses.

The antlers on this figure, as on all carousel deer, are genuine. Authentic antlers were not only readily available but were much stronger than any made of wood.

Last Operated - Unknown
Collection of John and Cathy Daniel
Restored by Tobin Fraley Studios
71" high, 48" long

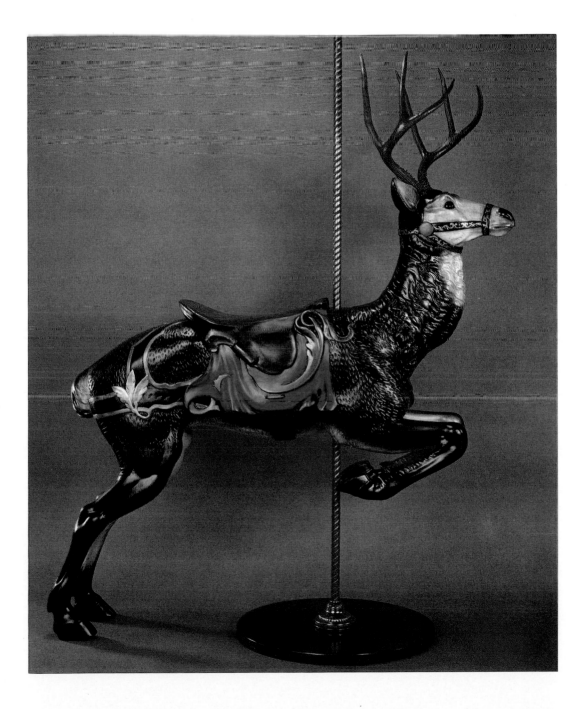

HERSCHELL-SPILLMAN ZEBRA c. 1912

All of Herschell-Spillman's zebras were carved without trappings, making them the only animals created that way by any of the major manufacturers. Not only are the stripes much more striking without interruptions, but there is a sense of wildness about an animal with no man-made accessories.

This zebra came from a class 1 carousel. Herschell-Spillman had 5 categories from which to choose, starting from class 5, a two abreast carousel of simple horses, to class 1, an extra fancy machine with a full menagerie.

Last Operated - Newton Lake, Carbondale, Pennsylvania
Collection of John and Cathy Daniel
Restored by Tobin Fraley Studios
46" long, 54" high

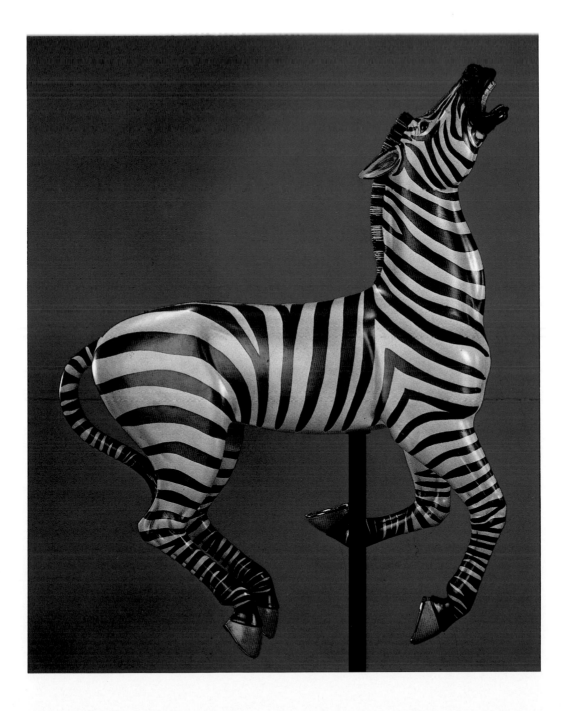

91

HERSCHELL-SPILLMAN SEA MONSTER c. 1912

 Mythical creatures were created by several companies, but in America they were always related to the sea. It is not known exactly where the inspiration originated, although tales of the Loch Ness Monster were prevalent at the turn of the century. To emphasize the untameable nature of these ferocious creatures, trappings were always kept to a minimum.

Operating - Tilden Park, Berkeley, California
Restored by the Redbug Workshop
66" long, 60" high

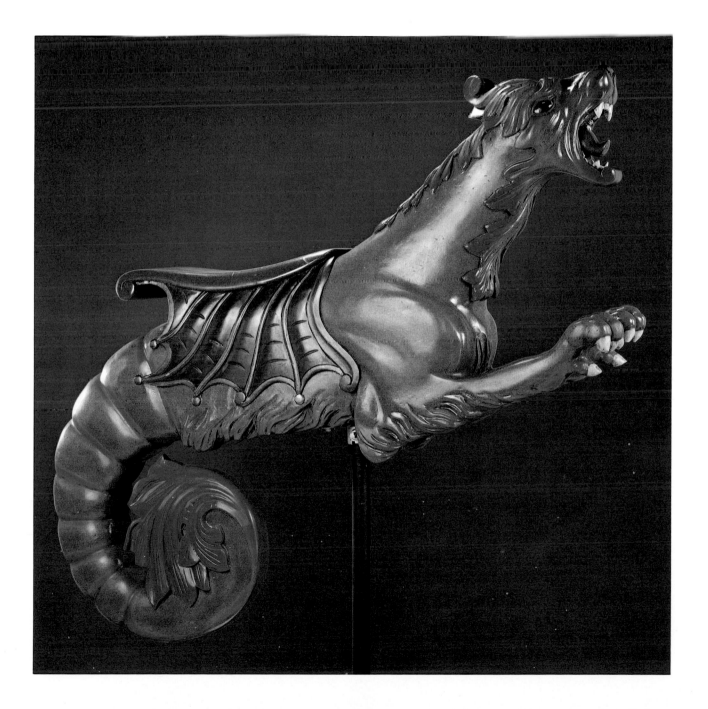

DENTZEL HIPPOCAMPUS c. 1895

The hippocampus, or seahorse, was born in Roman mythology. Neptune's chariot was pulled through the ancient seas by several of these magnificent beasts, and according to the myth, the Roman god was occasionally seen riding on one of their backs. Dentzel stopped making these creatures around 1900, and only four are known to have survived. This one endured a fire which charred much of the old paint giving the effect of just having come out of the ocean.

Last Operated - Neptune Beach, Alameda, California
Collection of the Freels Foundation
60" long, 72" high

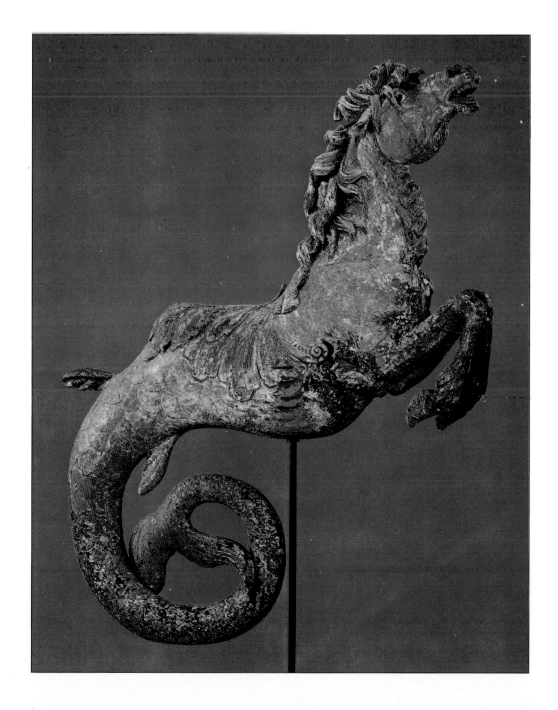

European Animals

The detail achieved by European carvers is well documented by the delicately crafted animals which ride the carousels throughout Europe. The intricate carvings represented on the following pages are even more remarkable when the quality of the wood is considered. American manufacturers were able to make their animals from well aged clear hardwood cut from plentiful forests. Europeans were limited to softer woods, usually filled with a variety of knots and twisted grain. Only true mastercraftsmen could create these finely carved animals from such materials.

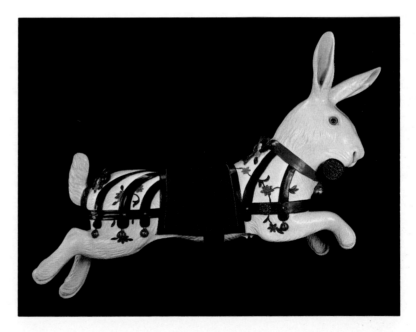

ENGLISH HORSE c. 1910

The ornate carving, parallel legs and double seat on
this horse by C.J. Spooner epitomize the English style.
Although Spooner produced thousands of horses at his
factory in Burton-on-Trent, it would be difficult to find
any two which were identical. The basic design varied
little, but the trappings and saddle were always changing.
As with some American firms, Spooner would identify
his carousels by carving his name on one of the animals.

Last Operated - England
Collection of Barbara Scavullo
57" long, 42" high

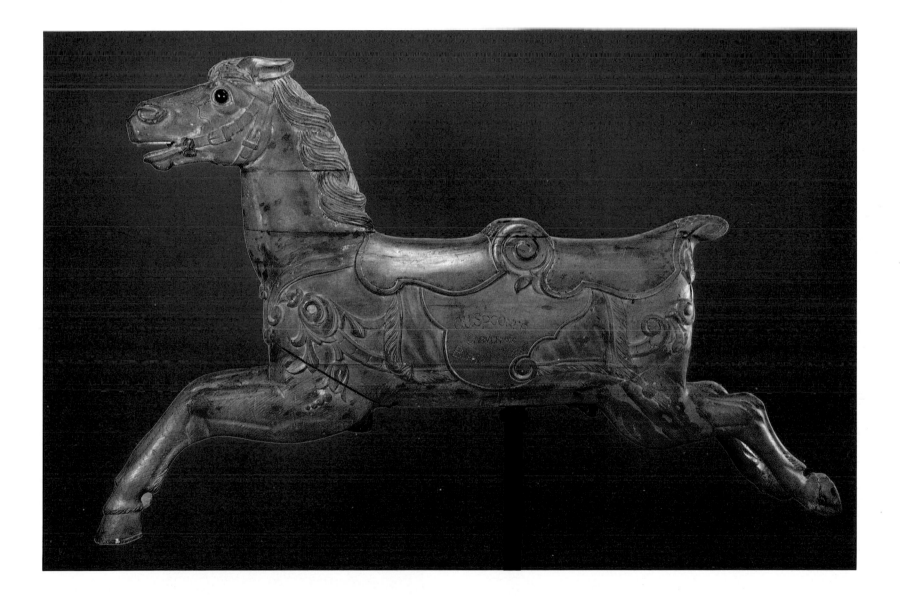

SPOONER CENTAUR c. 1900

During the Boer Wars of 1896-1899, several men achieved prominence as military heroes. To commemorate their bravery, C.J. Spooner of Burton-on-Trent immortalized these men by carving their likenesses on wooden centaurs. These representations proved very popular, giving children the opportunity to ride on the back of a legend. The figure represented here is of General Robert S.S. Baden-Powell, who after his excursions in Africa went on to become the founder of the Boy Scouts.

Last Operated - England
Collection of Rol and Jo Summit
Park Paint
72" long, 50" high

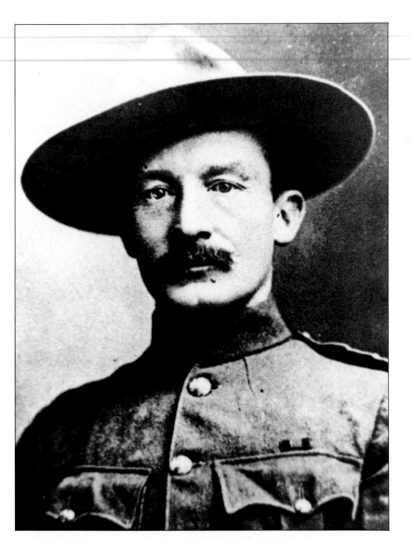

Photograph Courtesy of
Rol and Jo Summit

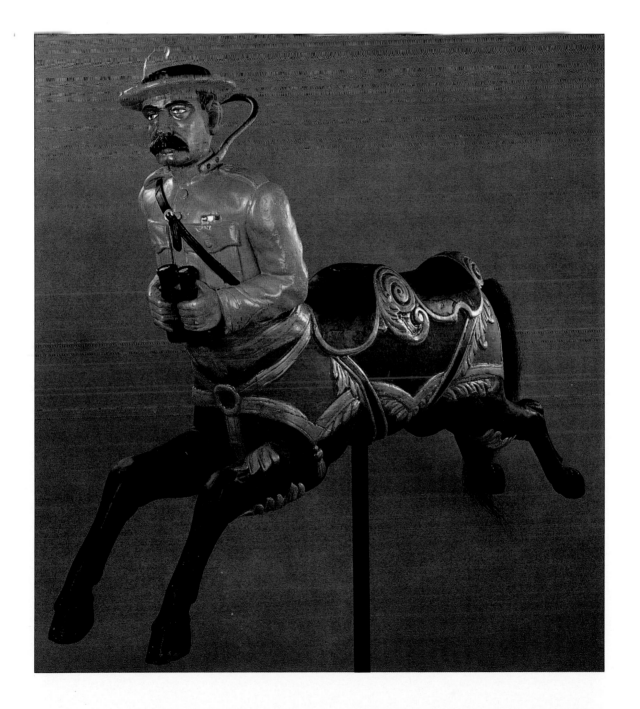

GERMAN HORSE c. 1904

This delicate prancing horse was crafted by Germany's premiere carousel carver, Frederick Heyn. It is mounted on the original mechanism which allowed the rider to rock the horse back and forth using his own body weight, while the carousel turned. The mane was carved so that it could be easily gripped, giving the patron greater balance while rocking. After restoration of the wood, this horse was painted in the original colors, recreating the flower patterns frequently used by Heyn.

Last Operated - Unknown
Collection of Mr. and Mrs. E.E. Trefethen
Restored by Tobin Fraley Studios
45" high, 48" long

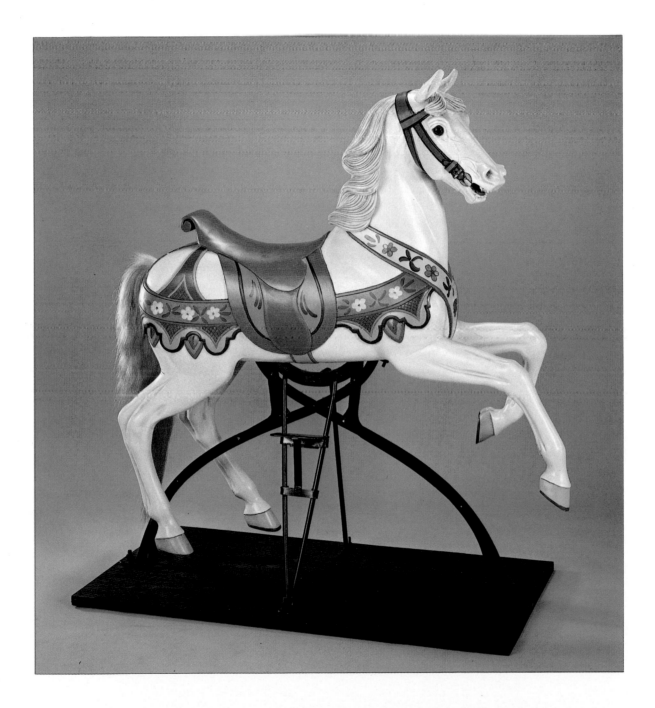

103

FRENCH PIG c. 1909

Carved by Gustave Bayol in Angers, this pig, complete with metal tail, appears to be using his ears to sustain flight. Although the ears seem to be oversized to produce this illusion, the pig was actually fashioned after a species of domestic pigs found in France. The Bayol pig was one of a number of barnyard animals that were quite popular on French carousels and was copied by both English and German carvers. The expression and pose remained the same in each case, only the trappings were altered to fit regional styling.

Last Operated - Unknown
Collection of Will Leighton
Restored by Tobin Fraley Studios
25" high, 57" long

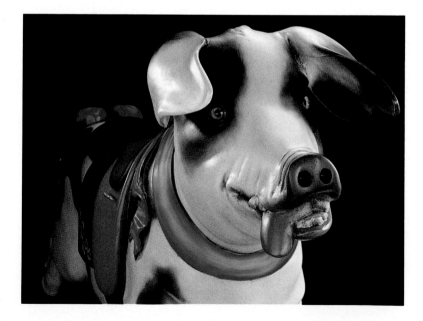

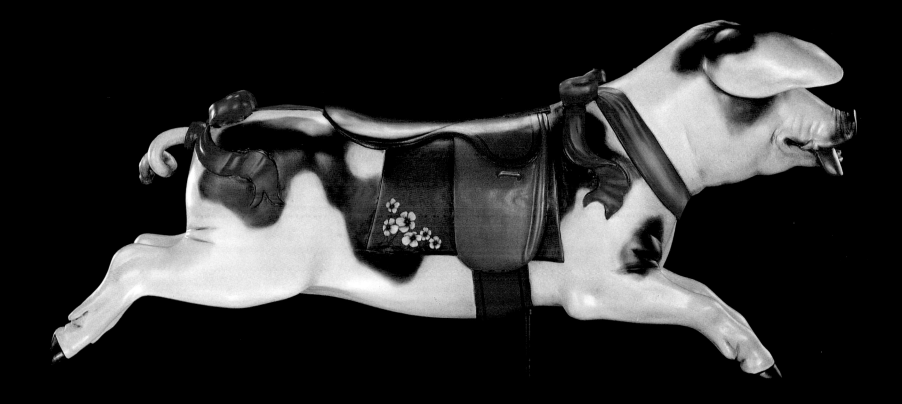

FRENCH RABBIT c. 1899

This Bayol rabbit holds a brass twenty franc piece, dated 1899, in its mouth and wears its maker's trademark on the front strap. Since this animal was created for the Grand Carousel at the Paris Exposition Universelle of 1900, it is larger and fancier than the majority of rabbits produced in France. Although the ribbons around the tail and neck were standard on Bayol's menagerie, the carved bells, flowers, and cloth seat were unusual extras added to enhance the animal for this occasion.

Last Operated - France
Collection of Rol and Jo Summit
Restored by Rol and Jo Summit
60" long, 30" high

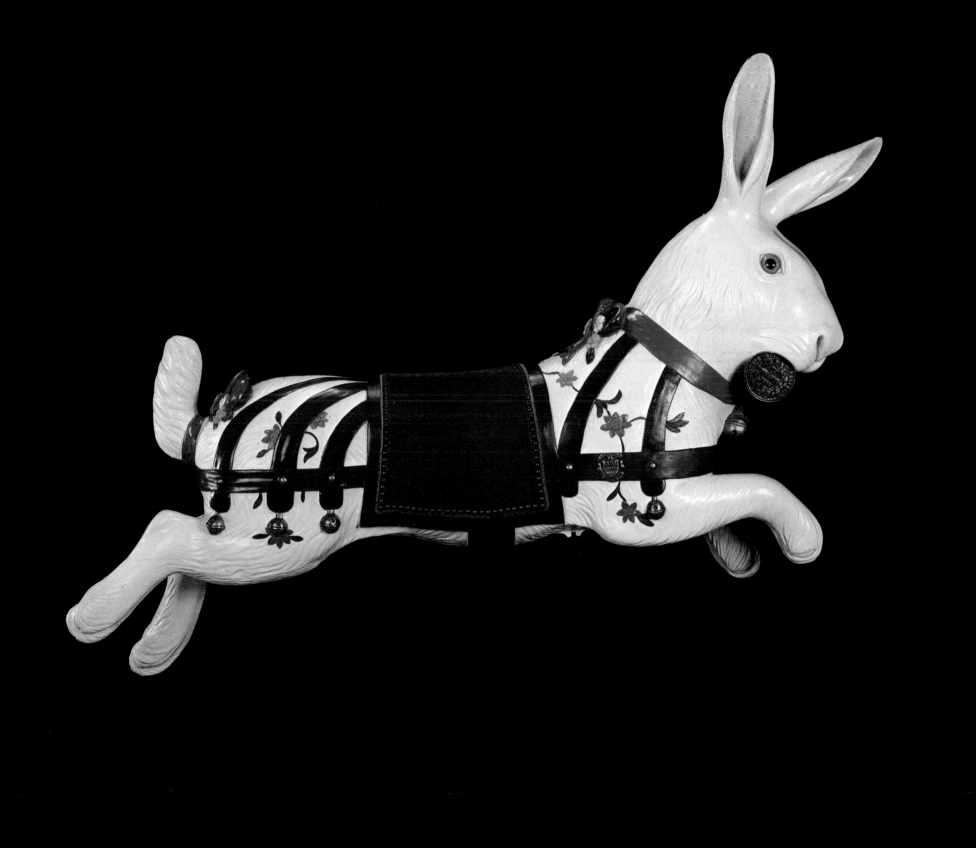

Chariots and Trim

All the trim pictured in this book is made out of wood, but many of the elaborate rounding boards and panels used on fancy carousels were cast in plaster. This enabled companies to create a complex cornice which could be molded repeatedly and used on numerous machines.

Once the animals were completed, placing them in the proper setting was crucial. Elegant Dentzels placed in simple surroundings can lose some of their splendor, while a Herschell-Spillman machine can become over-powered by massive trim. The entire ambience of the carousel rests upon the homogenous blend of animals and trim.

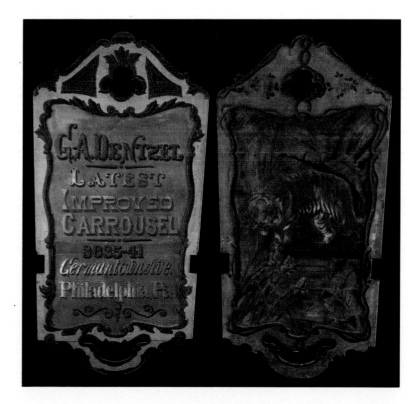

DENTZEL CHARIOT c. 1908

Carvers were usually restricted to creating likenesses of animals for the carousel, but when chariots were designed, imagination was given free rein. Besides conforming to the shape of the chariot, the only other guideline was that scenes stay within moral boundaries. Angels, eagles, and a variety of winged monsters were favorite themes. Steel rods were bolted through holes drilled in the carvings in order to support the seats and backs while keeping the sides together.

Last Operated - Edgewater Park, Dearborn, Michigan
Collection of the Freels Foundation
Restored by Maurice and Nina Fraley
78" long, 48" high

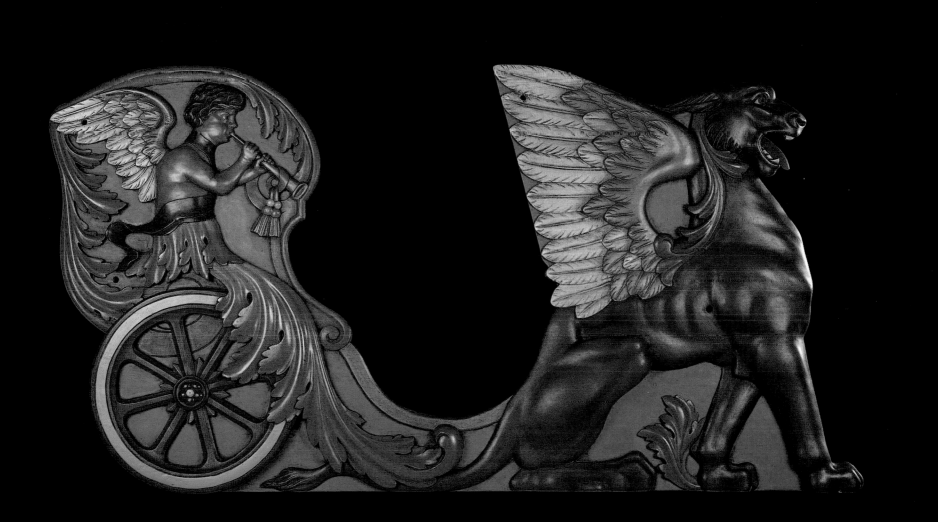

DENTZEL CHARIOT c. 1890

For those who wanted the experience of riding a carousel but were hesitant about climbing onto an animal, there were chariots or benches. Carousels usually carried two chariots fitted with two five foot benches accommodating three people each.

One of the difficulties encountered in designing the chariot side was developing a theme which conformed in shape to the preset pattern of the chariot. Here two ferocious creatures guard the entrance to the chariot, while holding a drape for the patron to step across.

Last Operated - Unknown
Collection of Bill and Marion Dentzel
Original Paint
50" high, 67" long

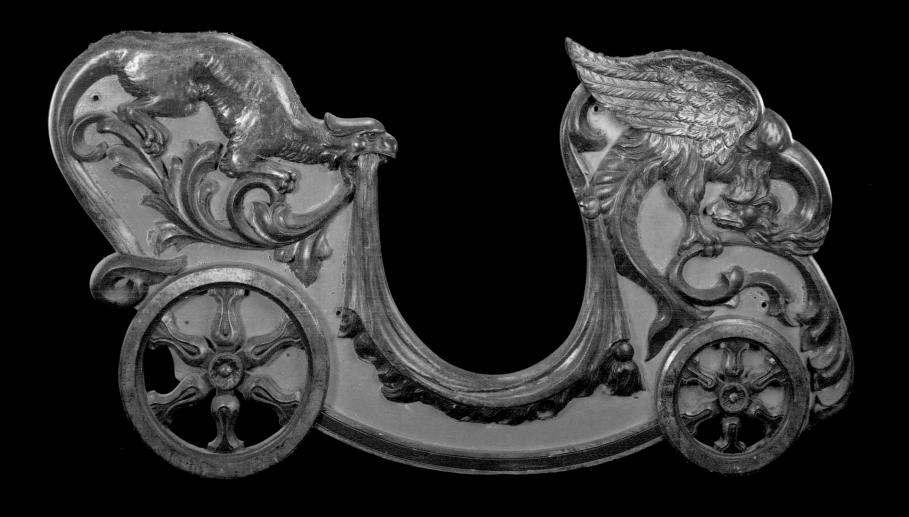

MULLER PANEL DIVIDERS c. 1910

In order to achieve a sense of continuity in the carousel structure, the joints or abutments of the large decorative panels were hidden by smaller panel dividers. These ornately carved lengths of wood made by Daniel Muller were used to cover the couplings of the panels around the inner working parts of the carousel. Most companies used a painted or mirrored board. The high quality of these partitions reflect Muller's dedication to craftsmanship and excellence.

Last Operated - Unknown
Collection of Marge Swenson
Restored by Marge Swenson
9" long, 50" high

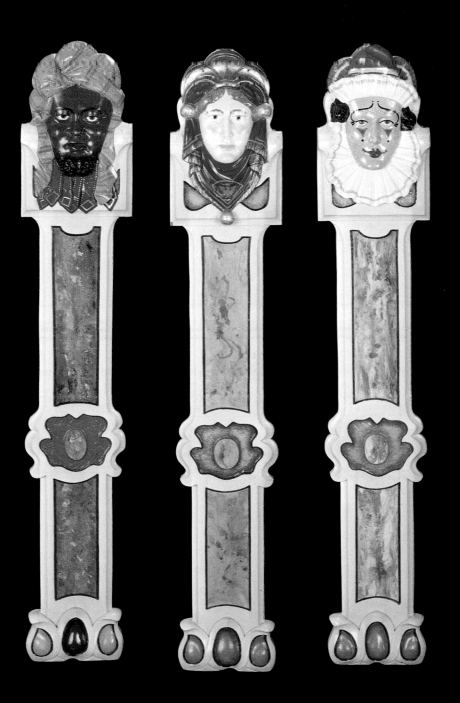

PHILADELPHIA TOBOGGAN COMPANY
ROUNDING BOARD c. 1906

Many of the scenes depicted on rounding boards were of a pastoral quality, evoking a sense of serenity. This same feeling is reflected throughout this particular carousel. The panels which decorate the inside around the mechanism show flowers draped in front of a peaceful sky while the animals themselves have the gentle expressions found on the early Philadelphia Toboggan Company machines. Since the backs of these rounding boards were visible from the platform, stencil patterns were applied in order to give the entire trim a consistent image.

Last Operated - Pine Grove, Pennsylvania
Collection of Maurice and Nina Fraley
Factory Paint
97" long, 29" high

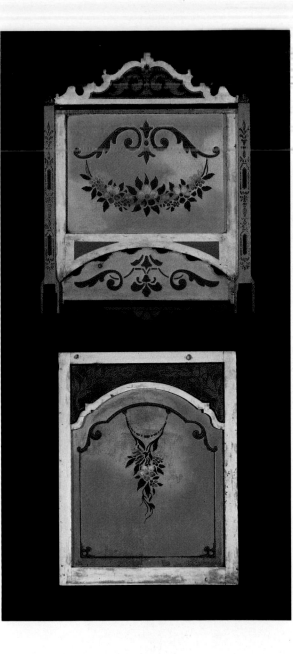

The Philadelphia Toboggan Company used stencils on most of the carousels they produced. Here they have created a beautiful pattern on canvas for this set of upper and lower panels. The strips of wood on the sides of the right hand panel are panel dividers (see previous page). Collection of Maurice and Nina Fraley

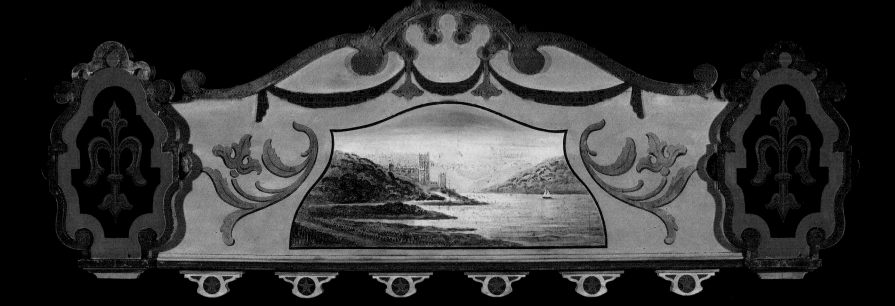

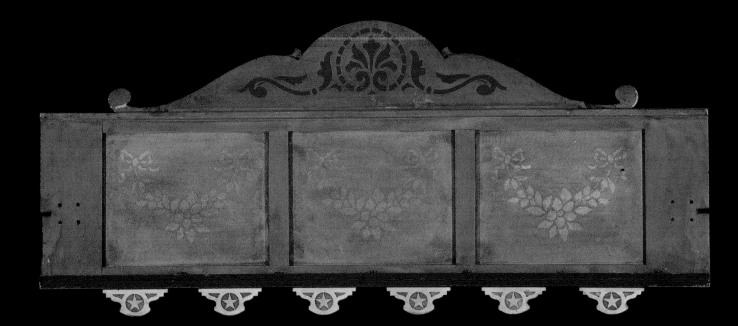

DENTZEL ROUNDING BOARD c. 1890

Americana played a large role in the themes painted on the trim of American carousels. Looff produced several carousels with portraits of presidents painted on the shields. Dentzel and the Philadelphia Toboggan Company would portray cowboys, buffalo and Indians on the western plains, while Parker captured rural scenes from the Midwest. This rounding board, in original paint, creates the illusion of a carved frame around the eagle clutching a flag and carrying a symbol for purity. By painting on shadows the painter was able to save the carver time and materials. The mirrors are encased in a carved wooden frame.

Last Operated - Dover, Pennsylvania
Collection of Maurice and Nina Fraley
Original Paint
9' long, 3' high

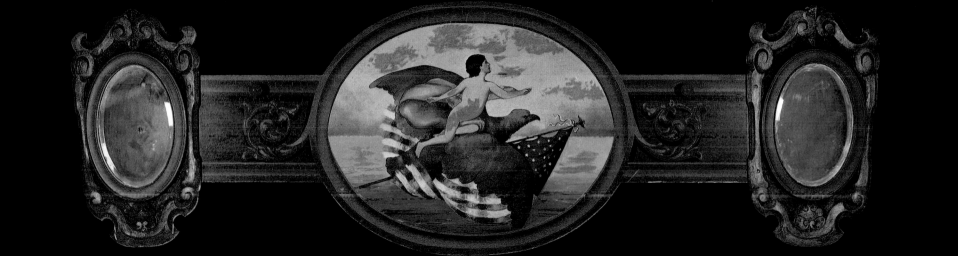

GUSTAV A. DENTZEL PANELS c. 1895

The basic purpose of a panel was to hide the interior working parts of the machine. The earliest panels were simply sheets of wood with a basic pattern painted on them, but as carousels grew fancier so did the panels. Many portrayed the fashions of the day, while others explored the secrets of the jungle, and of course, it was the perfect place to proclaim just who it was that had created this marvelous machine.

Last Operated - Unknown
Collection of Bill Dentzel
Original Paint
30" long, 66" high

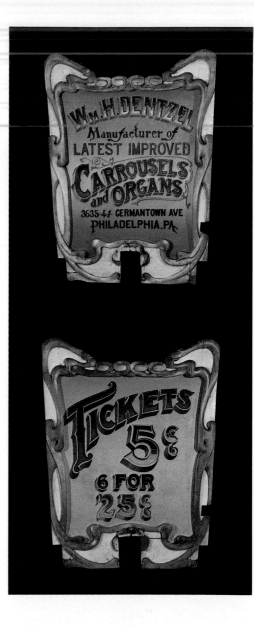

The carousel which bore these panels was manufactured by Gustav Dentzel in about 1890. Approximately 25 years later it was refurbished by the Dentzel Company, then under the direction of Gustav's son, William, who took the opportunity to update the panels.
Collection of the Freels Foundation

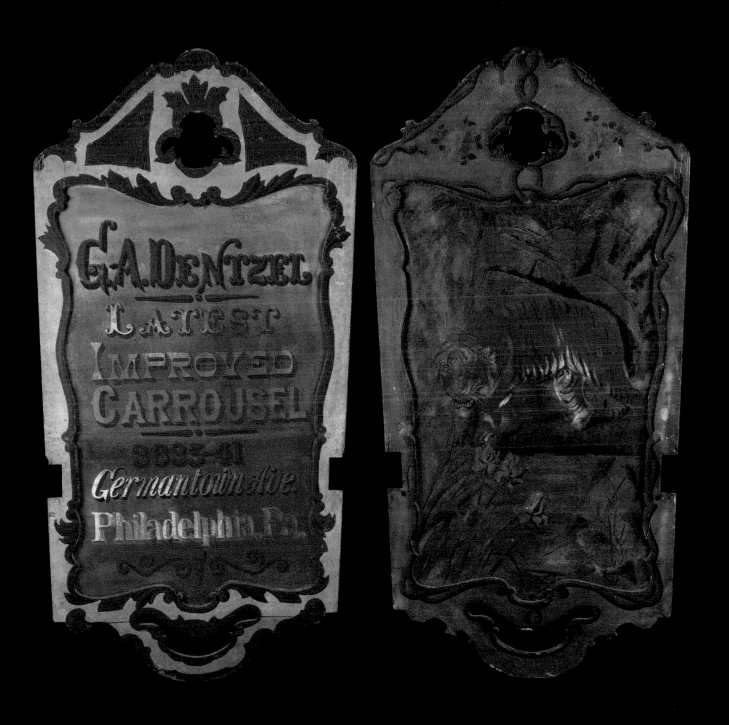

WURLITZER 146A BAND ORGAN c. 1922

Anyone who has ever ridden a carousel will say that
the ride is not complete without the wondrous sound of
a band organ playing a Strauss Waltz or a Sousa March.
The atmosphere would fill with the resonance of a
hundred pipes while the bass drum and cymbals kept time.
Numbers of companies produced band organs in both
Europe and the United States, including several carousel
companies. Wurlitzer was the leader in the field,
manufacturing an array of organs with as few as forty
pipes to as many as two hundred fifty pipes and horns.
The organ pictured here is of medium size and was one
of the most popular on working carousels.

Last Operated - Santa Monica Pier,
 Santa Monica, California
Collection of John and Cathy Daniel
Facade Restored by Tobin Fraley Studios
Mechanism Restored by Dan Hornberger
86" long, 62" high

Photograph by Maurice Fraley

122

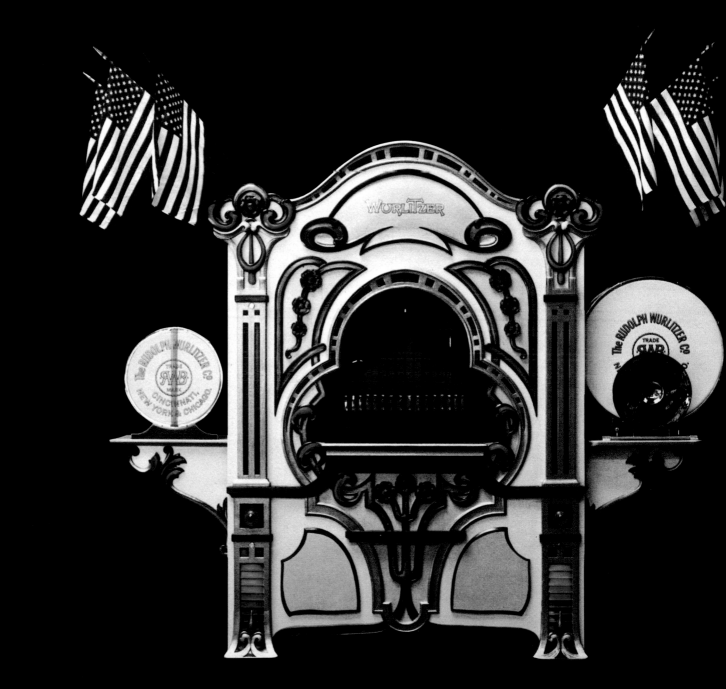

Epilogue

The demise of the hand-carved carousel animal came slowly over a period of twenty years in three distinct stages. When the age of mechanization produced a device which could rough carve the heads and bodies from a preset pattern, many carousel manufacturers began producing animals of identical design. Although a number of carvers were put out of work it was nonetheless a boon to the industry. When the Depression arrived, the demand for carousels declined sharply. The companies that survived either ceased making carousels, or like the Allan Herschell and Parker companies, produced very simple machines. The final blow came in the 1940's with the widespread use of aluminum and the advances made in the casting process.

The last of the wooden steeds were carved as patterns for aluminum horses. Most of the travelling carnivals that now appear at local fairgrounds have metal carousels produced by the Chance Manufacturing Company which bought out the Allan Herschell Company. Many of the fine examples of carving from the golden age of carousels have been copied in fiberglass and are beginning to appear on machines in parks across the nation.

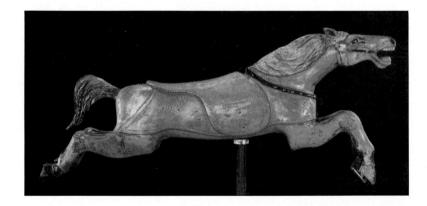

GLOSSARY

ABREAST The number of concentric rows of animals on a carousel, for example, a three abreast carousel has three animals side by side.

ARMORED Trappings which resemble medieval armor, the protective coverings worn by both rider and horse in battle or pageantry.

CANTLE The raised portion at the back of a saddle.

CAPARISON A medieval word referring to the equipment and coverings of an animal; trappings.

CAROUSEL A revolving machine carrying animals and sometimes chariots, designed to be ridden for amusement. The figures are generally of wood but are also found in fiberglass or metal. Also carrousel, carroussel or carouselle.

CARVING MACHINE A machine which uses a preset pattern to produce carving reliefs in rough form.

CENTER POLE The center support of a carousel from which the entire structure is suspended.

CHARIOT On a carousel, a stationary structure, fitted with benches and frequently with wheels, resembling in style the ancient Roman conveyances or baroque coaches. The sides were elaborately carved and painted usually with mythological figures or patriotic themes.

CONEY ISLAND STYLE The style depicted by very spirited horses, carved in poses of great motion, often having wildly flowing manes and containing glass jewels. Companies which carved in this style: Looff, M.C. Illions, Stein and Goldstein, and Carmel.

COUNTRY FAIR STYLE The style depicted by highly stylized animals, simplistic in design, usually produced for small rural fairs or travelling carnivals. Companies which carved in this style: the Parker Amusement Company, C.W. Dare, Armitage Herschell, Herschell-Spillman, Spillman Engineering Corporation, and Allan Herschell Company.

CROPPED MANE A mane which has been clipped short, usually two to three inches long. Also called a roached mane.

DERBY RACER A machine with carved horses attached to a rotating platform connected to the underbelly of the horse by a pole. As the platform rotates, the horses move forwards and backwards, each in a four foot long slot, giving them a galloping motion and creating the illusion of a horse race.

EAGLE BACK SADDLE A saddle with an eagle head carved on each side of the cantle. Usually associated with Dentzel and early Looff carvings.

FACTORY PAINT Paint which has been applied by a carousel company that is not necessarily the original carver of the figure.

FLYING JENNY An early form of the carousel, where the wooden animals hung freely by poles attached only to the overhead structure.

INSIDE ROW The row of animals closest to the center pole.

JEWELS Glass inserts, usually faceted and of various shapes and colors, which simulate precious stones.

JUMPER An animal which is designed to have all four feet off of the carousel platform and which moves up and down as the machine turns.

KEYHOLE JOINT A method of joinery consisting of a slot near the hip of an animal into which a corresponding part of the back leg fits to form a tight joint.

LEAD HORSE The fanciest horse on a machine, always found in the outside row and sometimes inscribed with the maker's signature or initials.

MENAGERIE FIGURE An animal other than a horse.

MERRY-GO-ROUND See carousel. This term is found in use as early as 1729 in England. Although most of the producers of these machines referred to them as carousels, merry-go-round has always been the name most popular with its patrons.

MIDDLE ROW(S) The row(s) of animals between the inside and outside rows.

MILITARY Trappings which feature realistic military equipment. Daniel Muller is best known for carving these detailed renderings of saddles, bedrolls, canteens, swords, etc., that were precise replicas of U.S. Army issue.

MIXED MACHINE A carousel with figures manufactured by several different carving companies.

ORIGINAL PAINT The paint that a carousel figure or trim has when it initially leaves the manufacturer.

OUTSIDE ROW The outermost row of animals which also has the largest figures on the platform.

PANEL Made of wood or of canvas with a wooden frame, these tableaus were made to conceal the mechanisms at the center of the carousel.

PARK PAINT Paint which has been applied to the animals and chariots by those operating the carousel as part of maintenance or restoration.

PHILADELPHIA STYLE This style is epitomized by carousel animals with a realistic and elegant look. First created by Gustav Dentzel, it was later adopted by other companies that formed in Philadelphia. Companies which carved in this style: the Dentzel Company, D.C. Muller and Brother, and the Philadelphia Toboggan Company.

PLATFORM The floor of the carousel which is suspended from the sweeps by means of steel rods.

PRANCER A stationary animal with the front legs raised and the back feet on the platform.

RABBIT HIDE GLUE An adhesive made from boiling the skins of animals. The gelatinous extract liquifies when heated, jells upon cooling, and hardens with subsequent drying to provide a strong resilient bond.

ROMANCE SIDE The side of the animal which faces toward the spectator as one approaches the carousel. Usually carved more elaborately than the inside. On American carousels, the romance side is on the right, on English machines, the left.

ROUNDABOUT British terminology, see carousel. English carousels moved in a clockwise direction as opposed to American carousels which ran counter-clockwise.

ROUNDING BOARDS The decorative boards covered by either plaster or carved wood, painted with a variety of scenes, and attached to the outer perimeter of the sweeps. With the shields they form a decorative cornice around the outside border of the carousel.

SHIELD Oval, round or shaped like a medieval coat of arms, shields are wood or plaster, sometimes set with mirrors. The shields hide the joints between the rounding boards; together they form a decorative cornice around the outside border of the carousel.